Just ADD *Color*

FAIRYLAND

BARRON'S

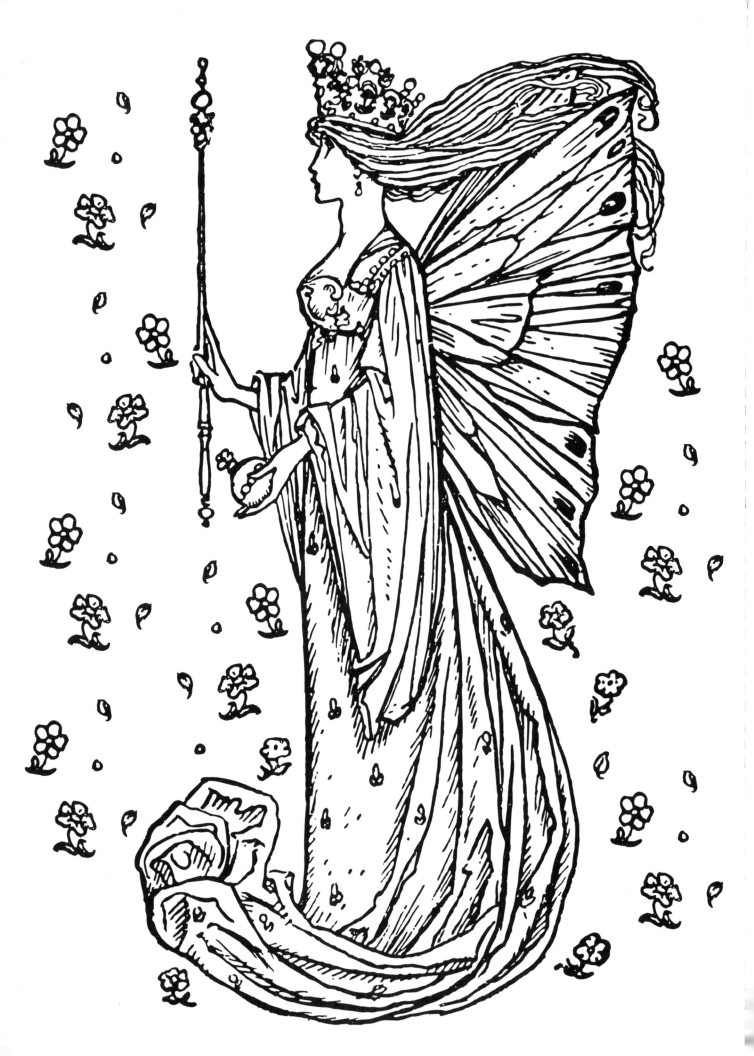

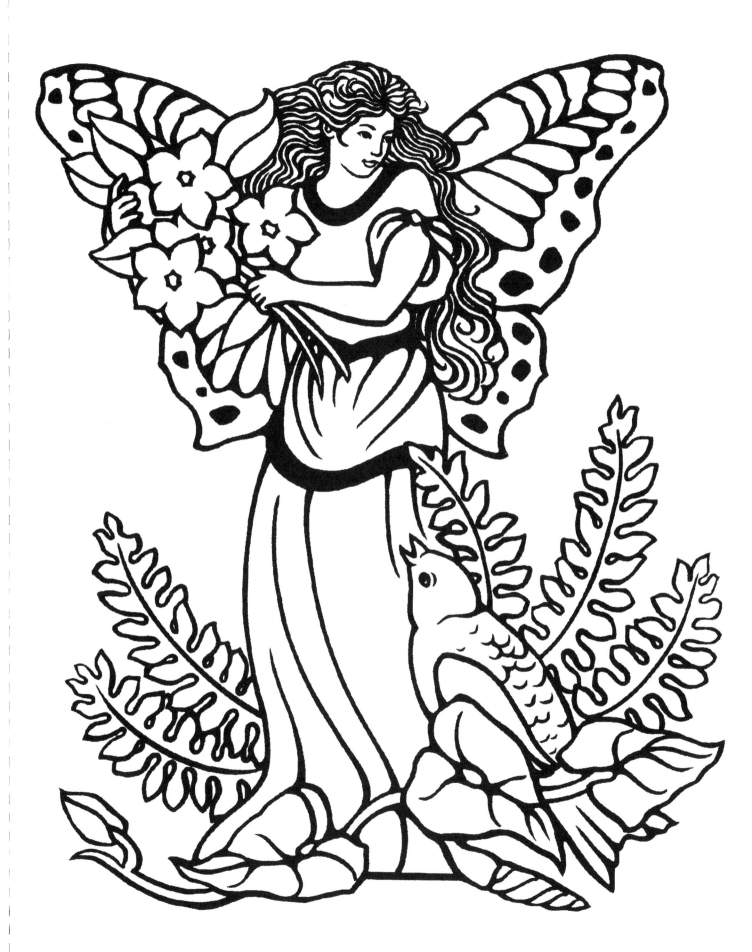

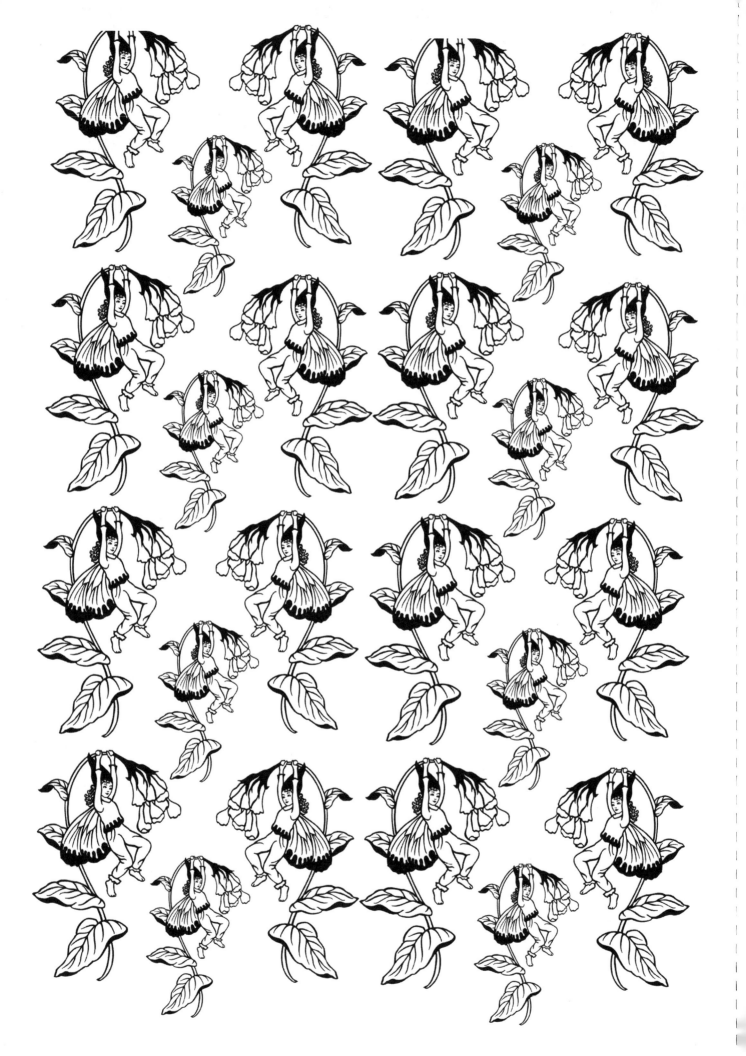

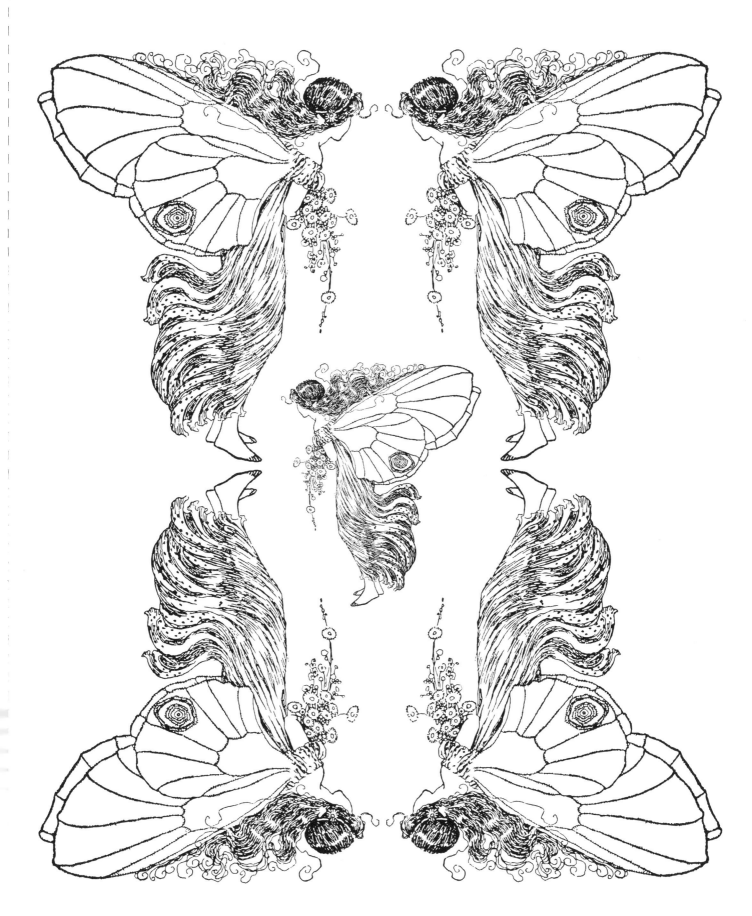

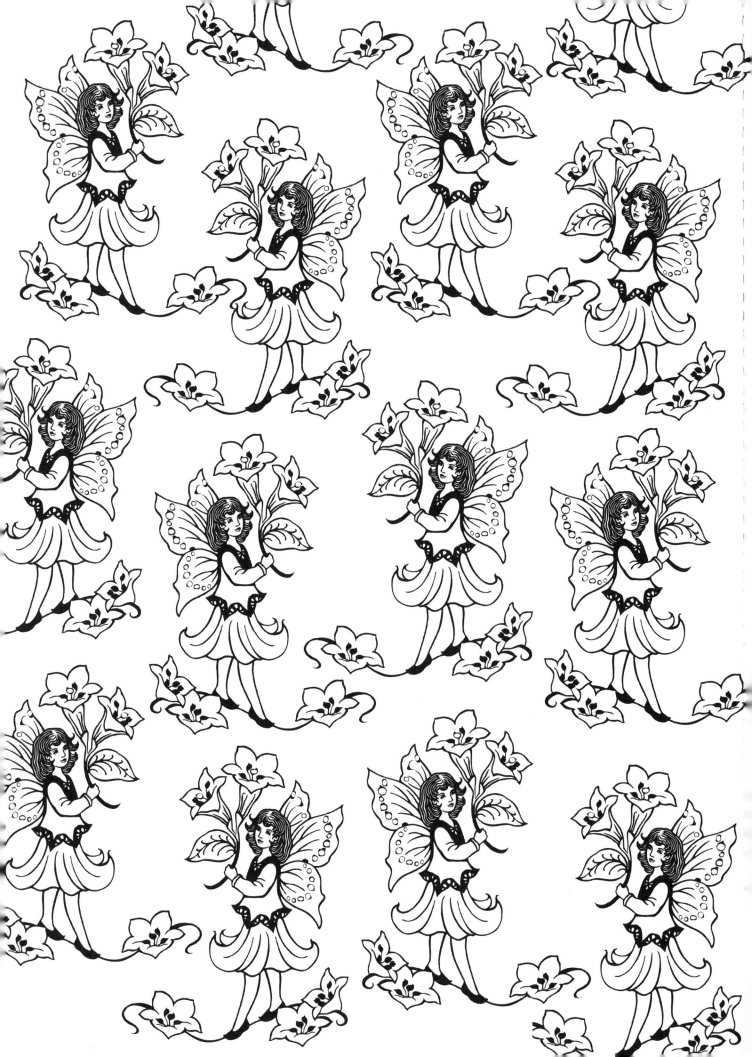

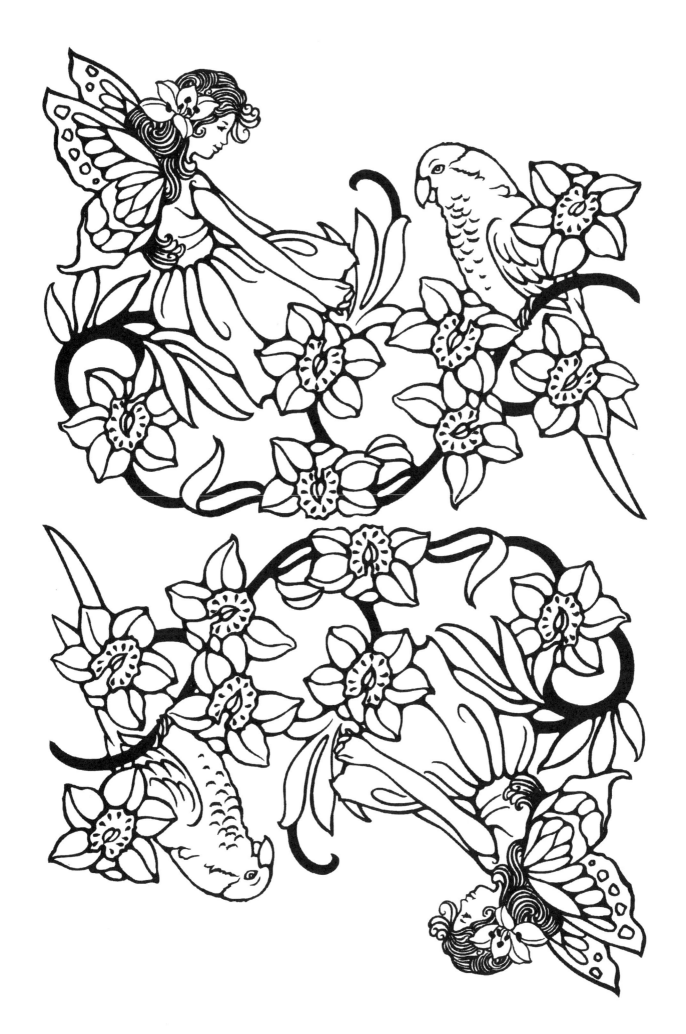

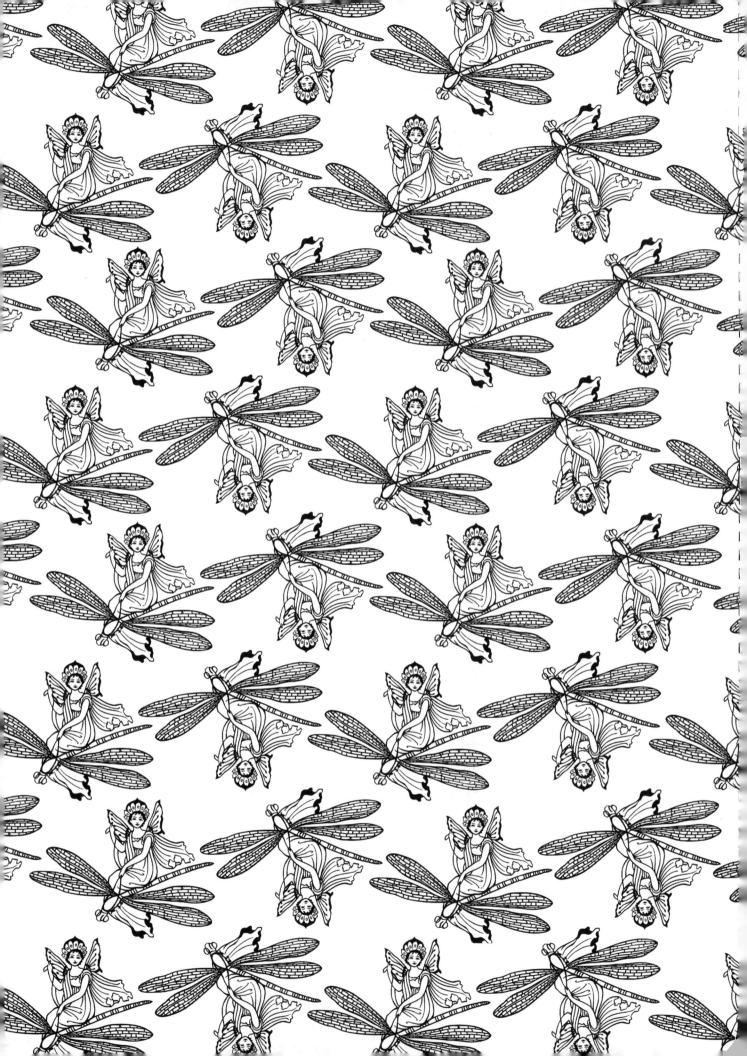

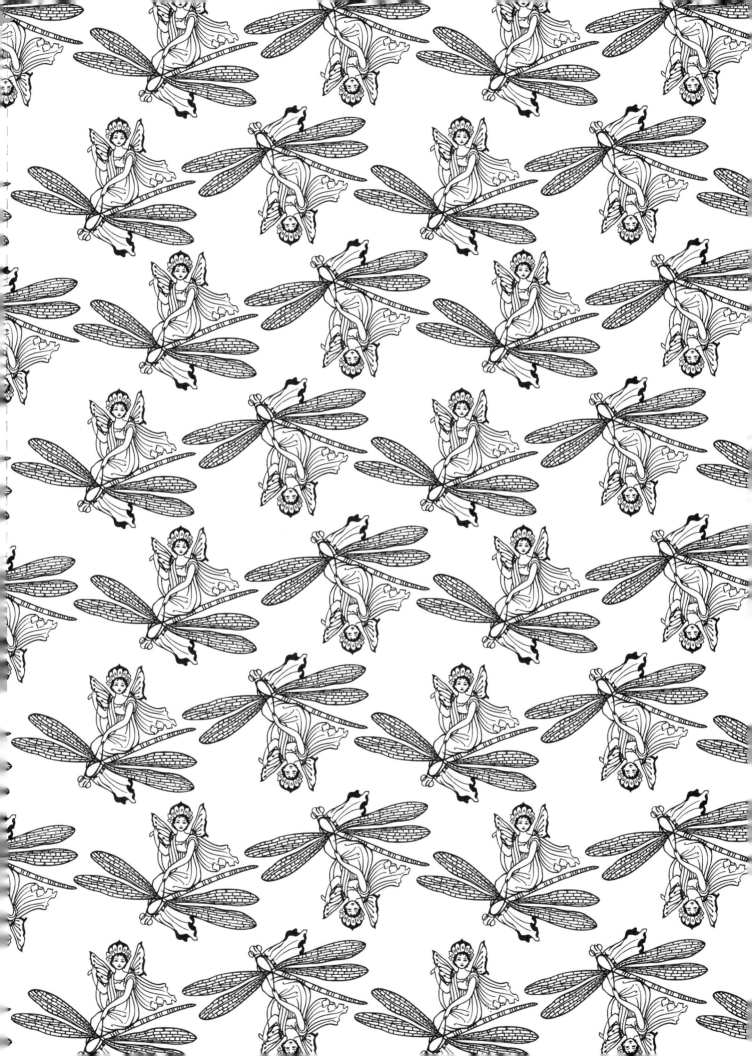

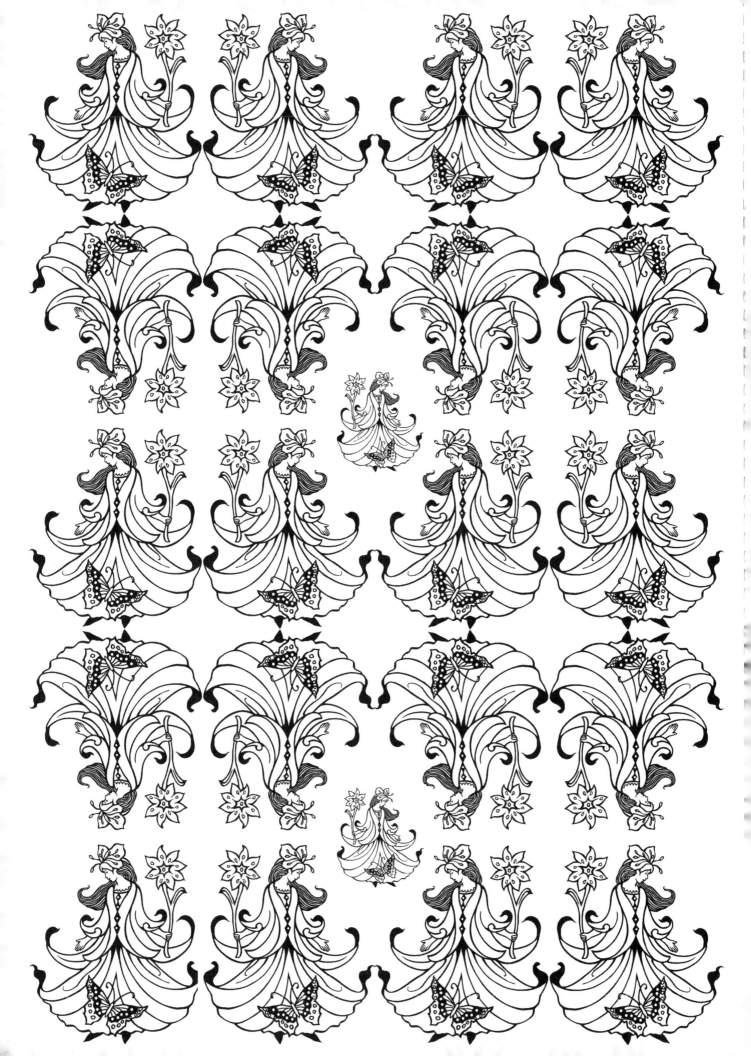

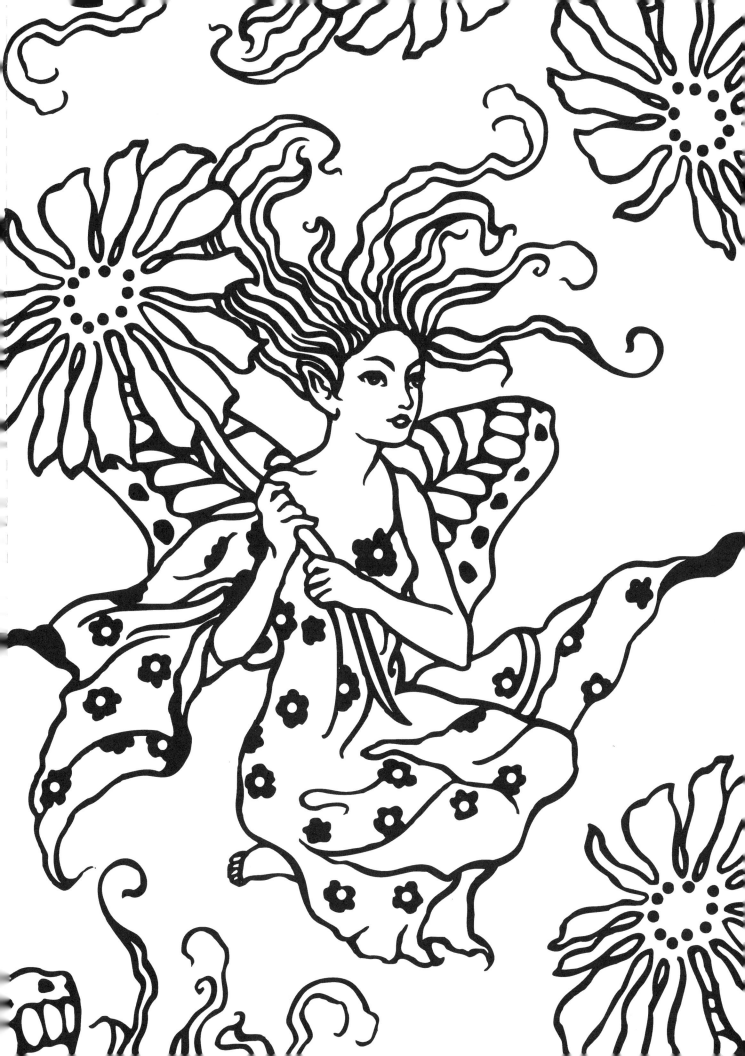

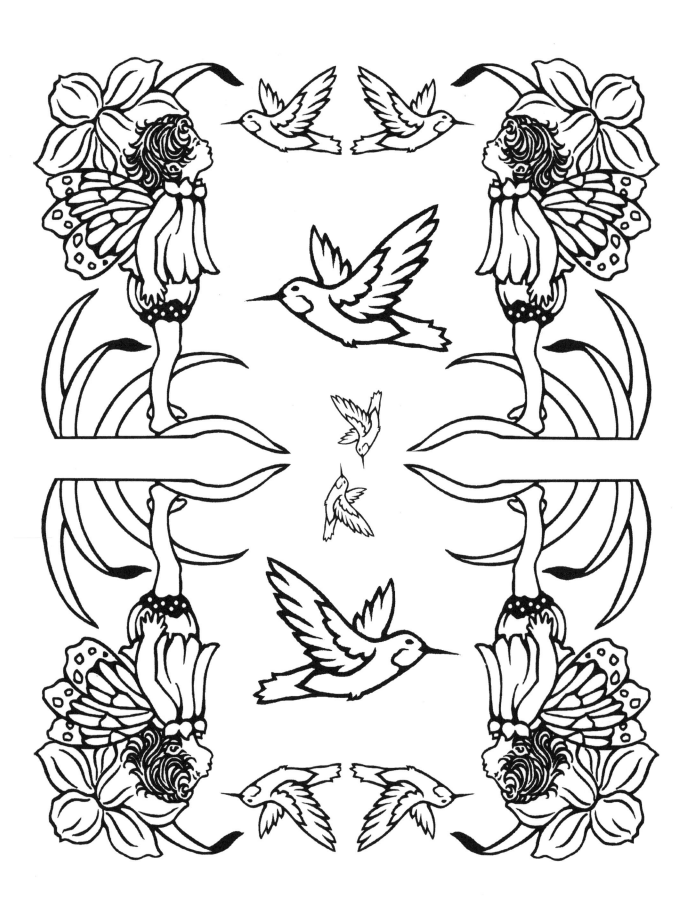

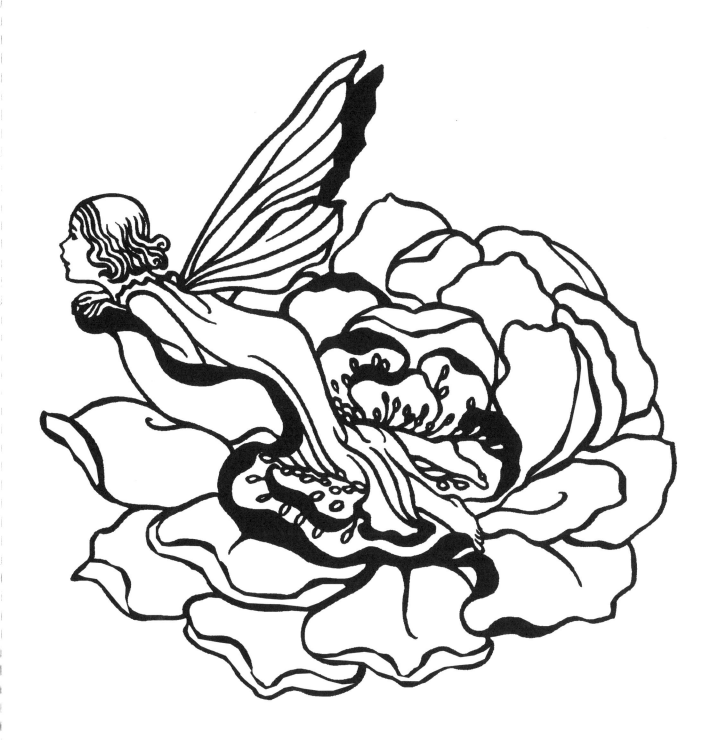

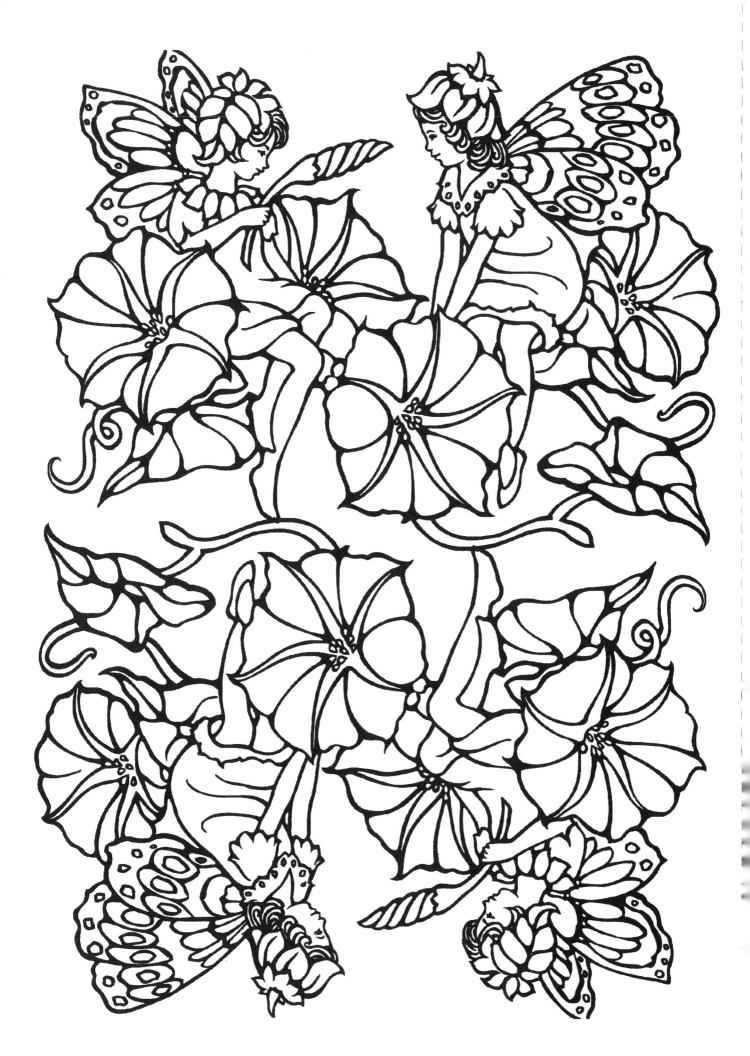

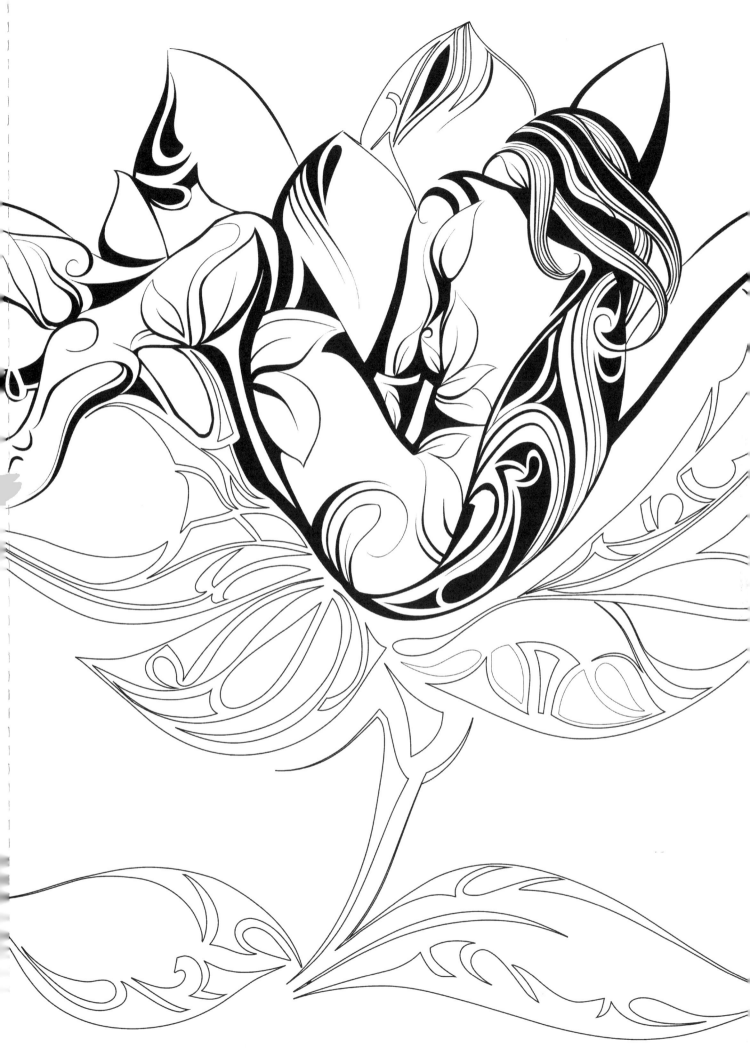

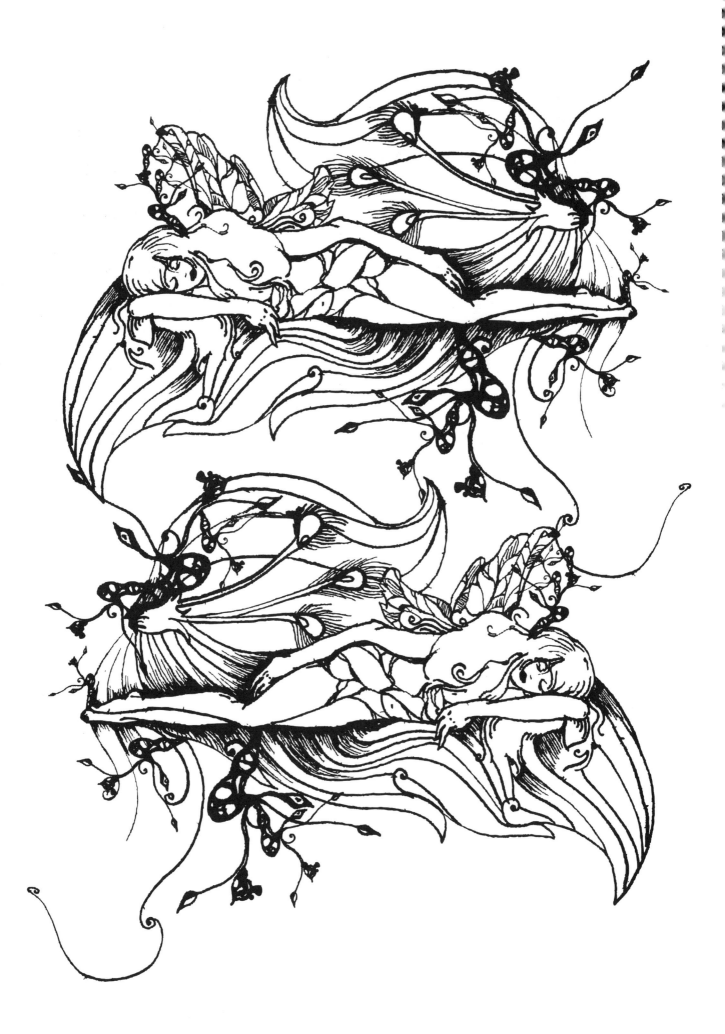

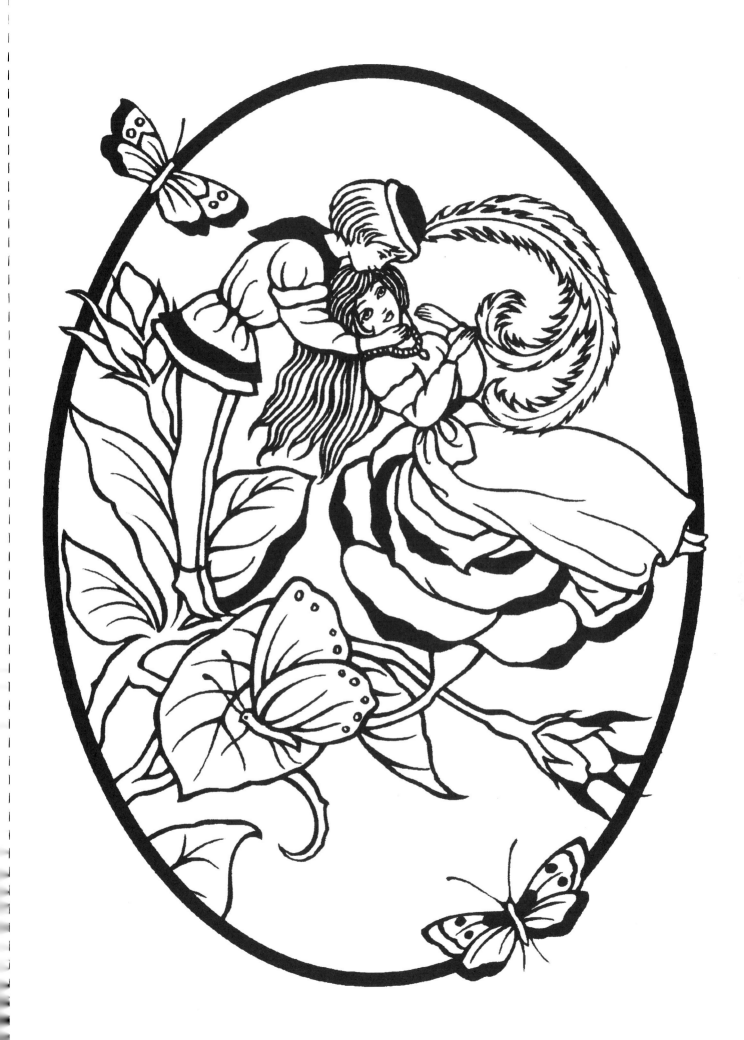

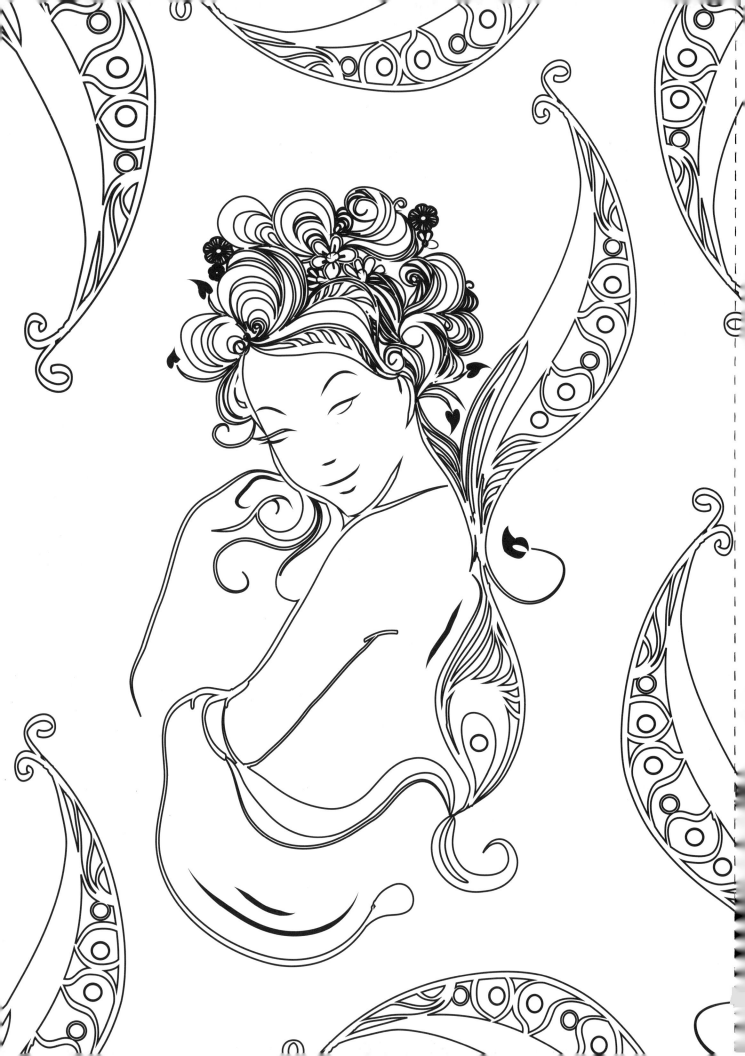

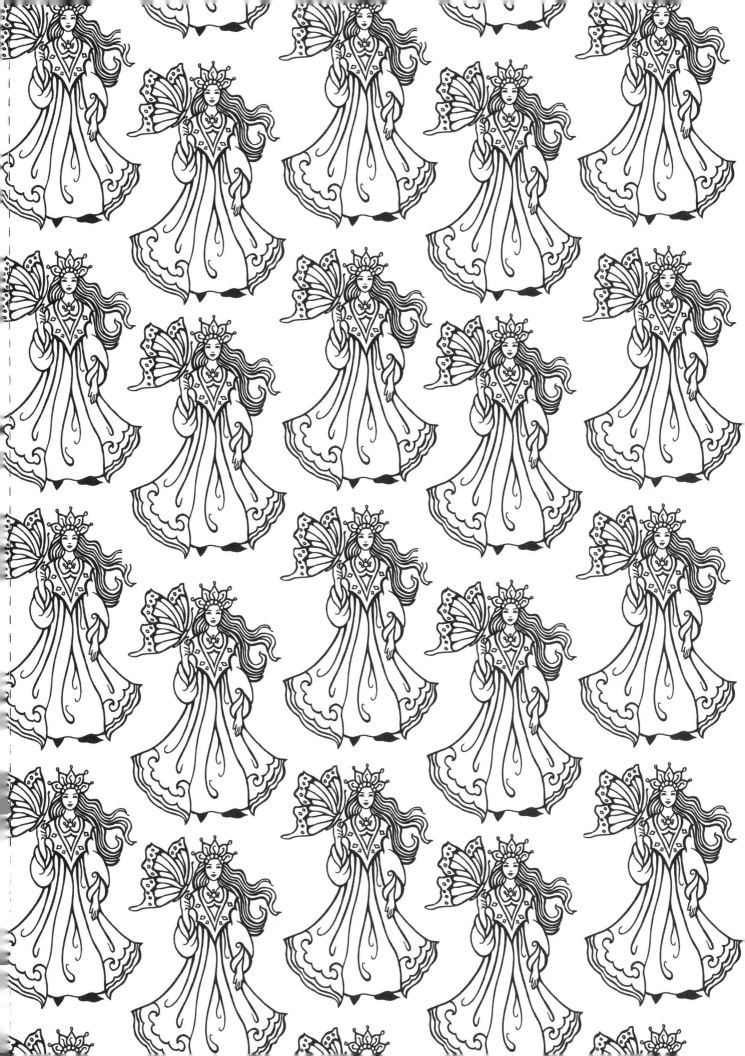

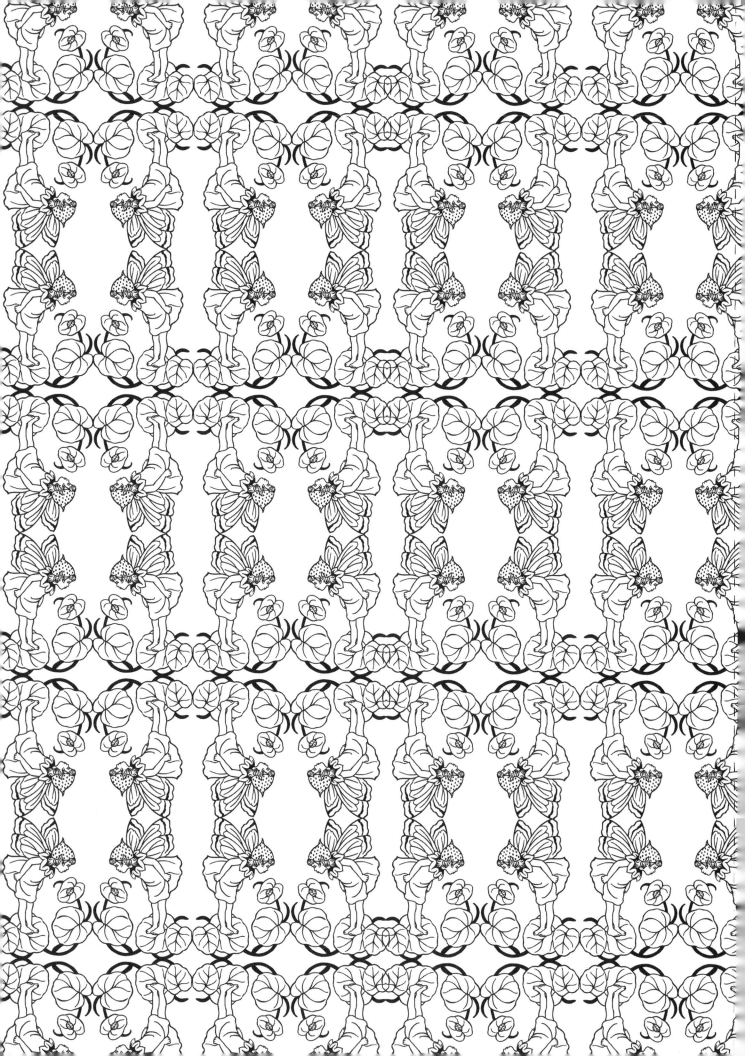

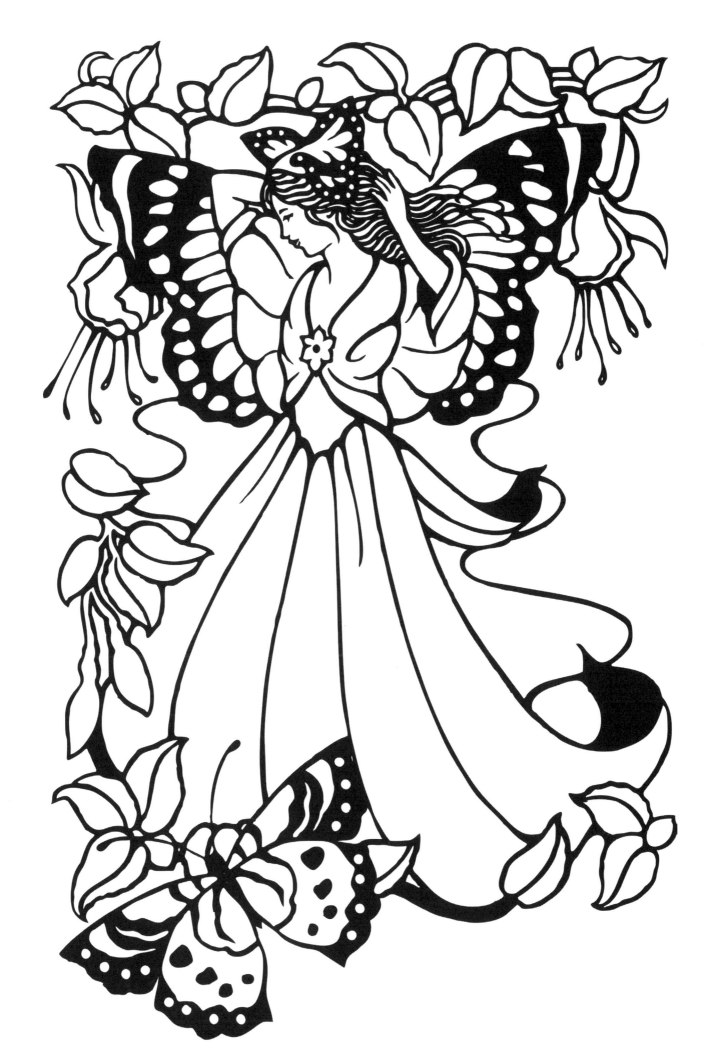

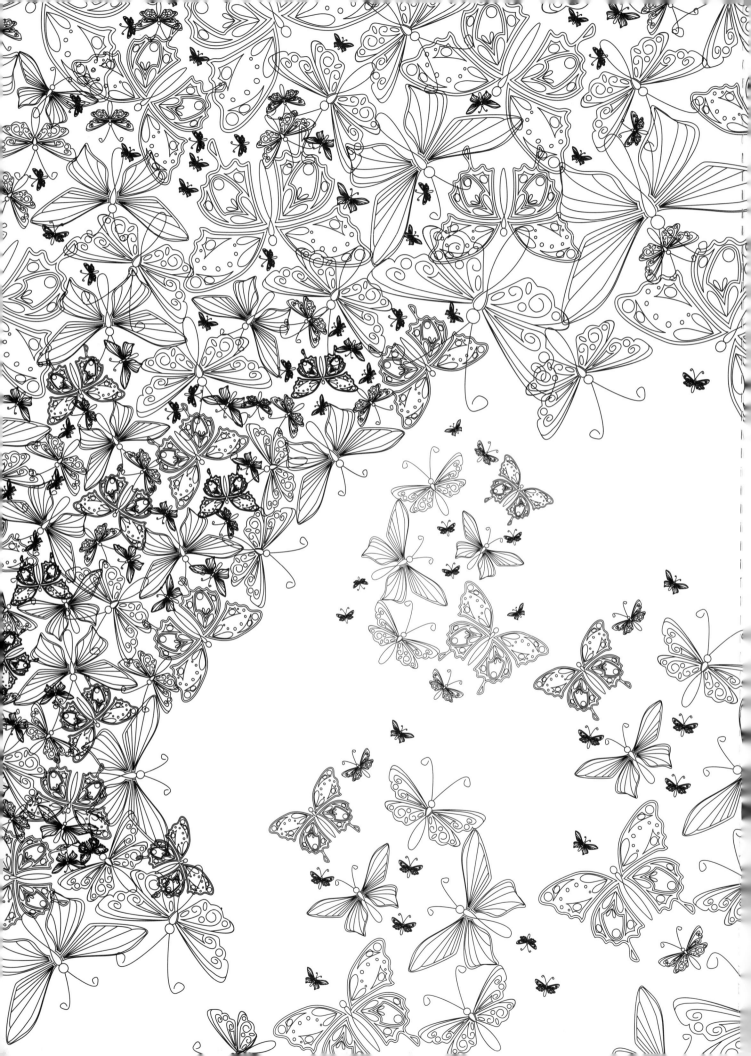

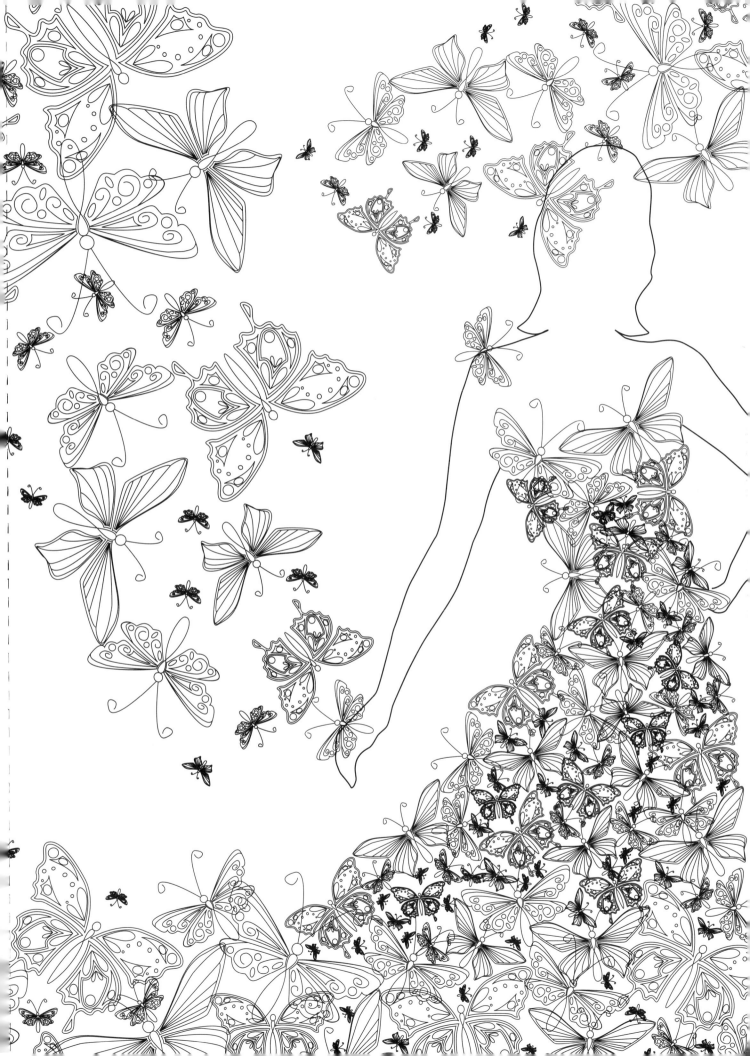

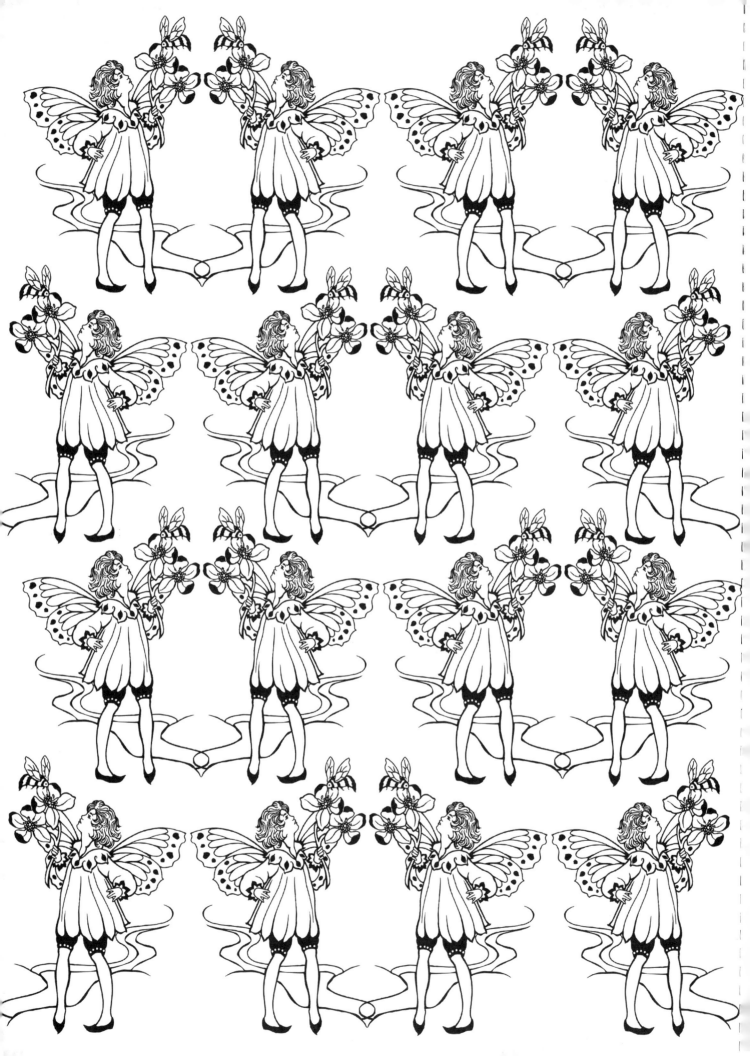

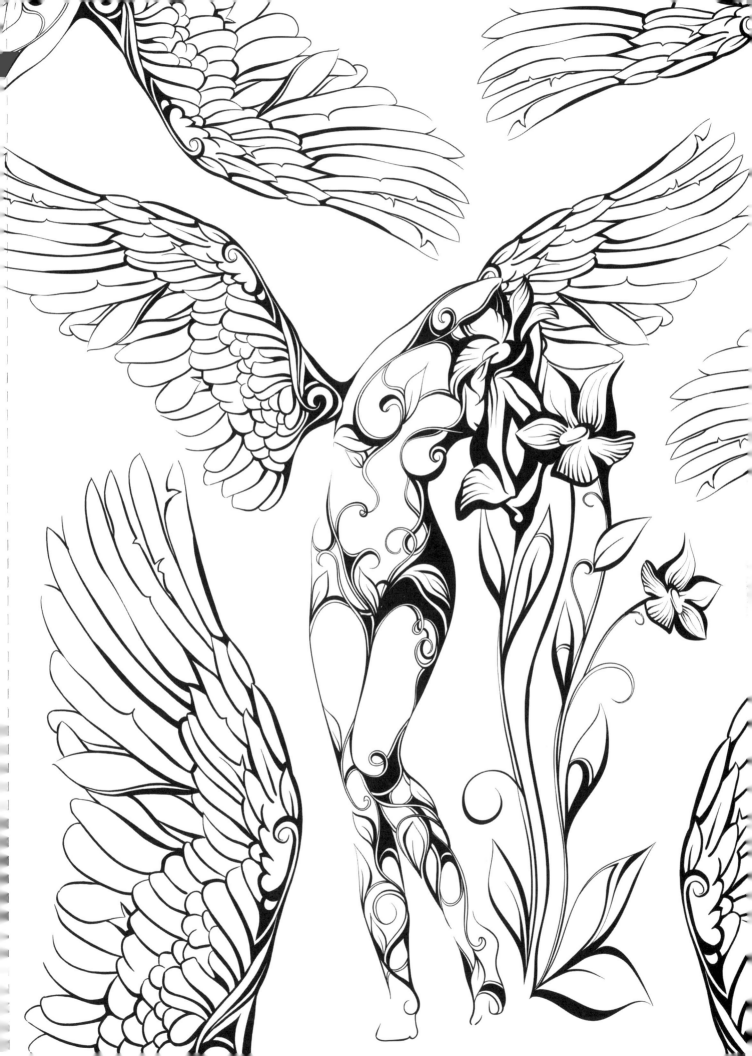

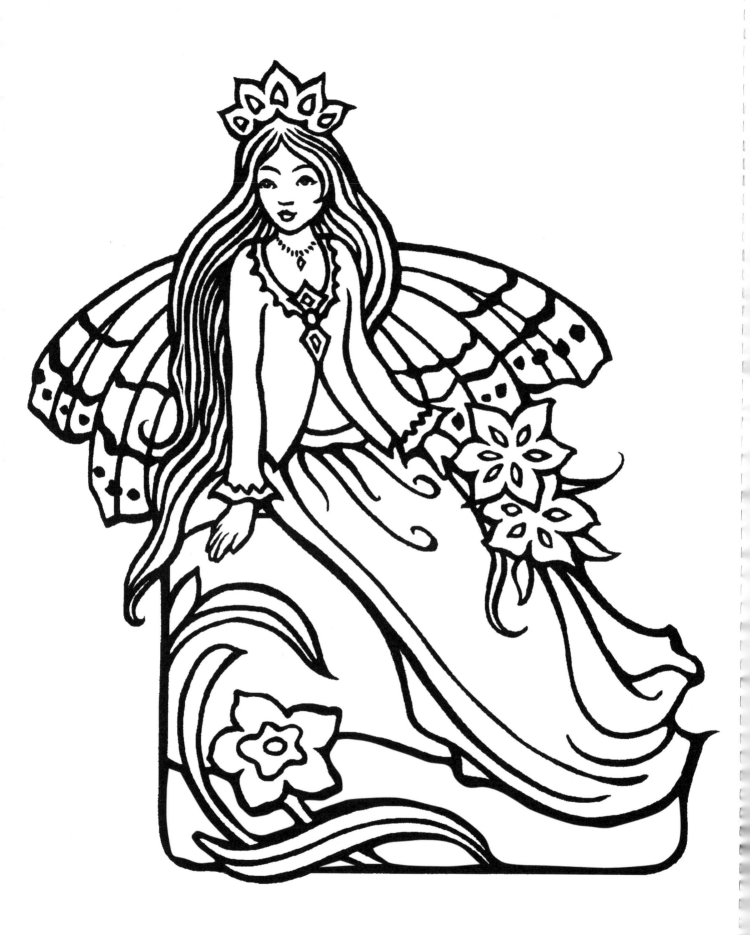

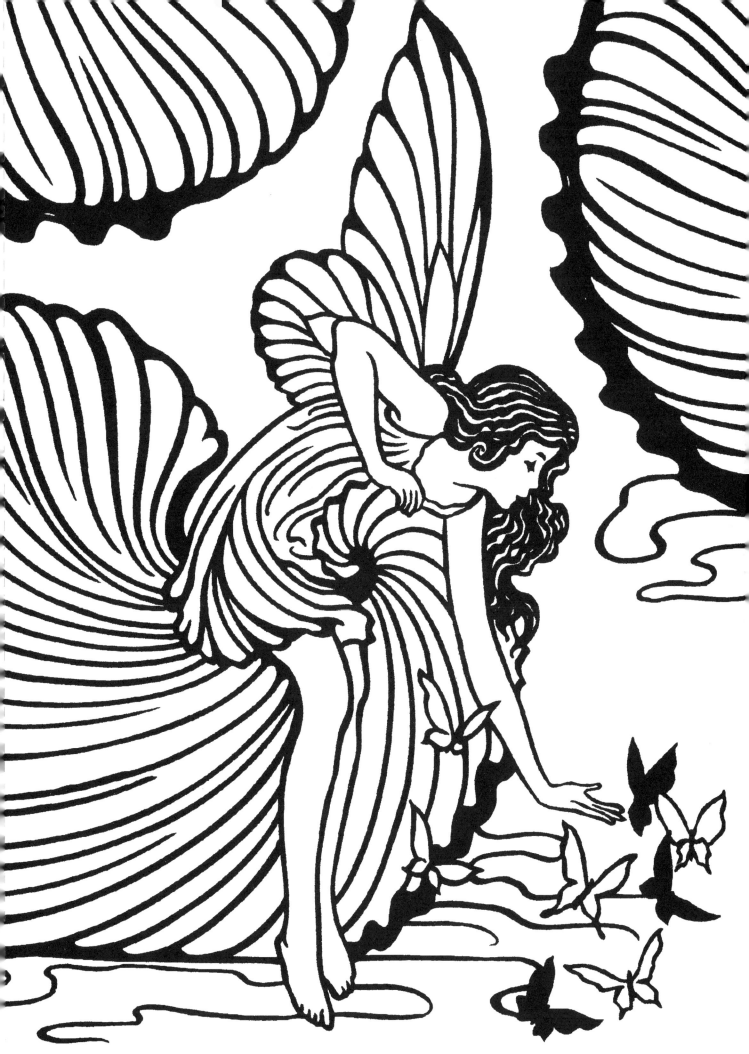

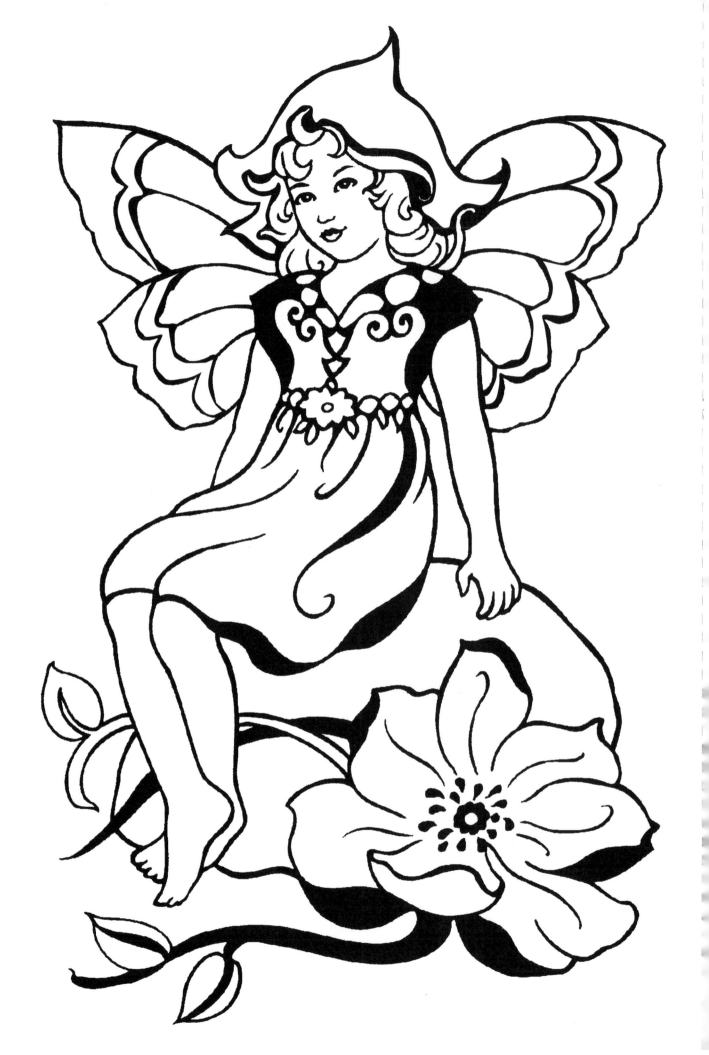

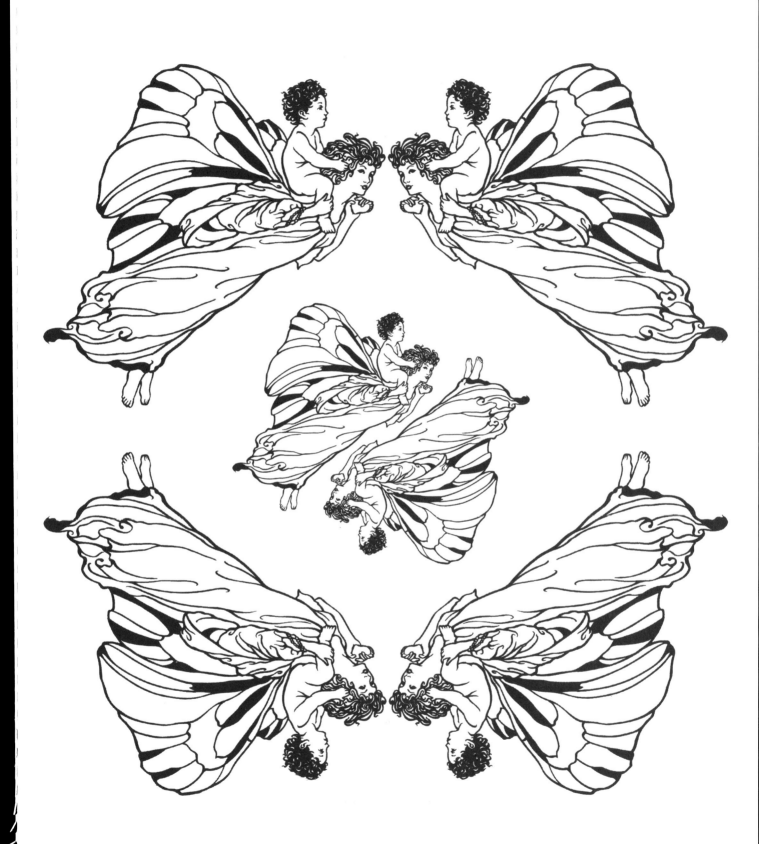

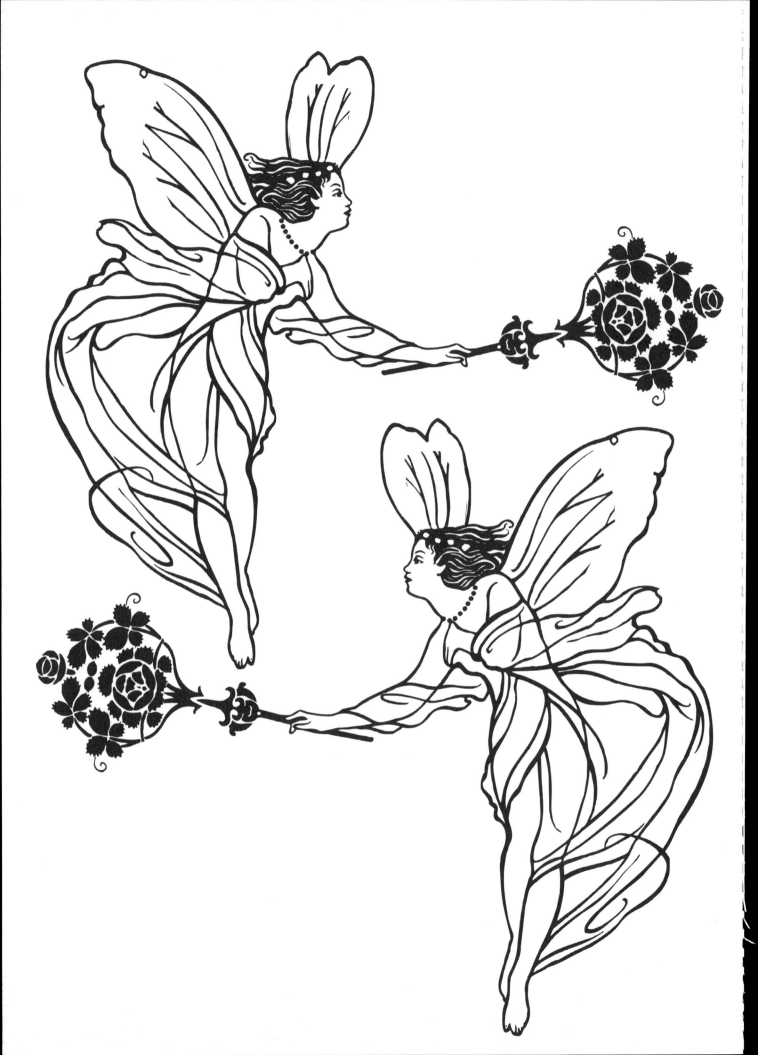

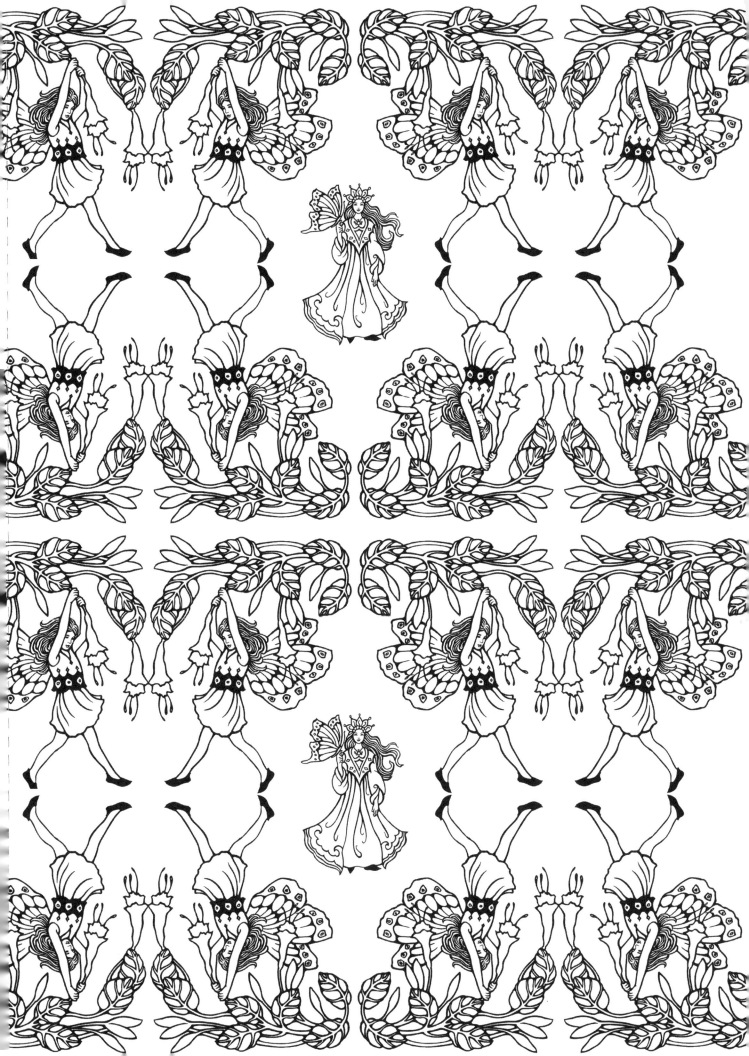

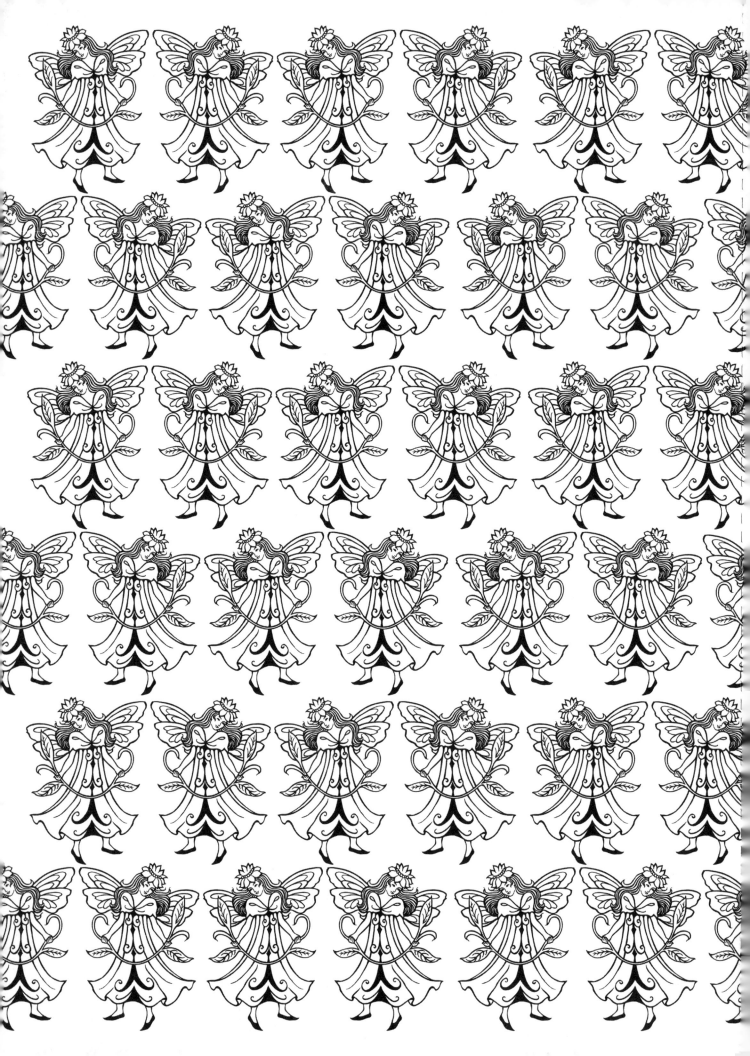

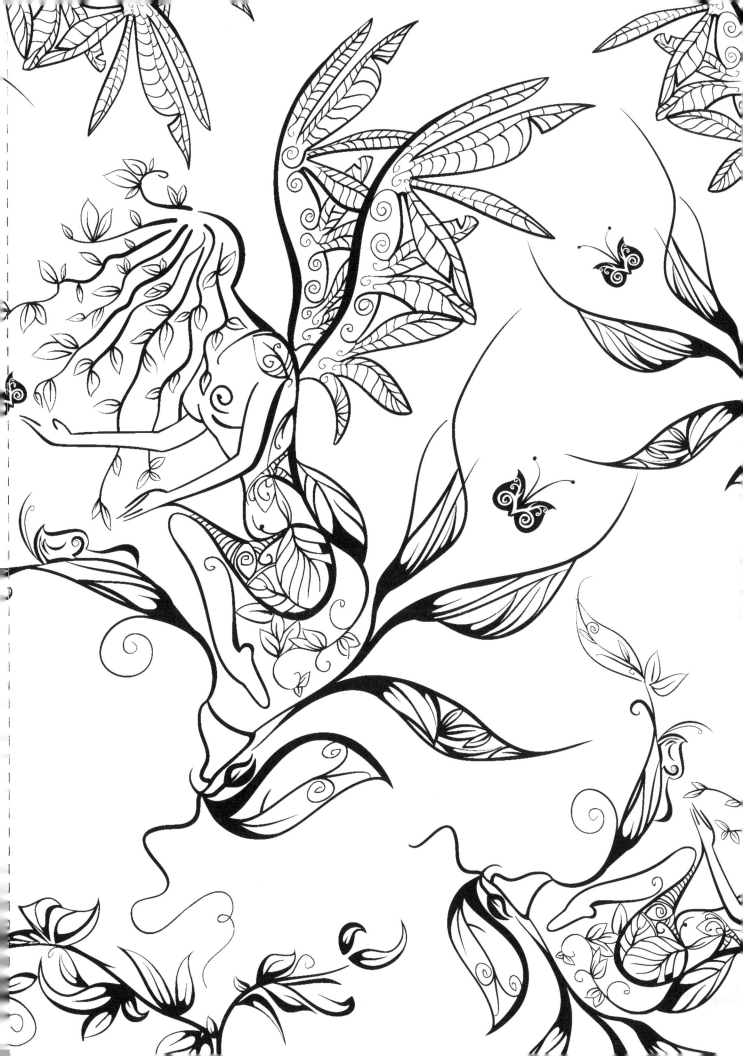

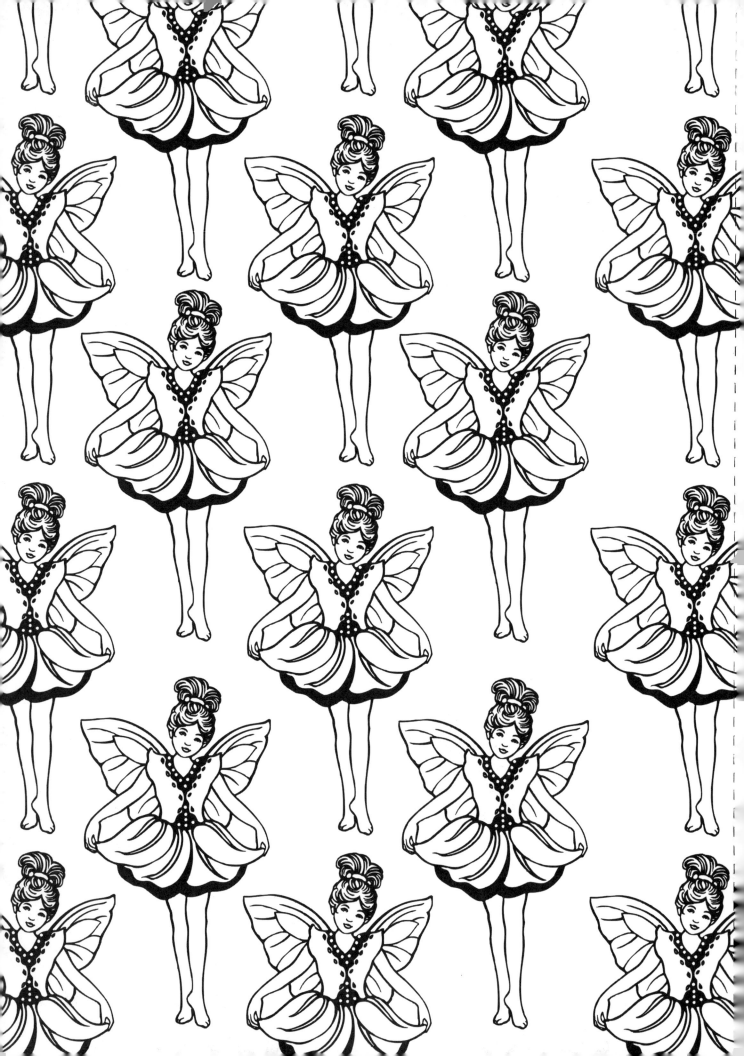

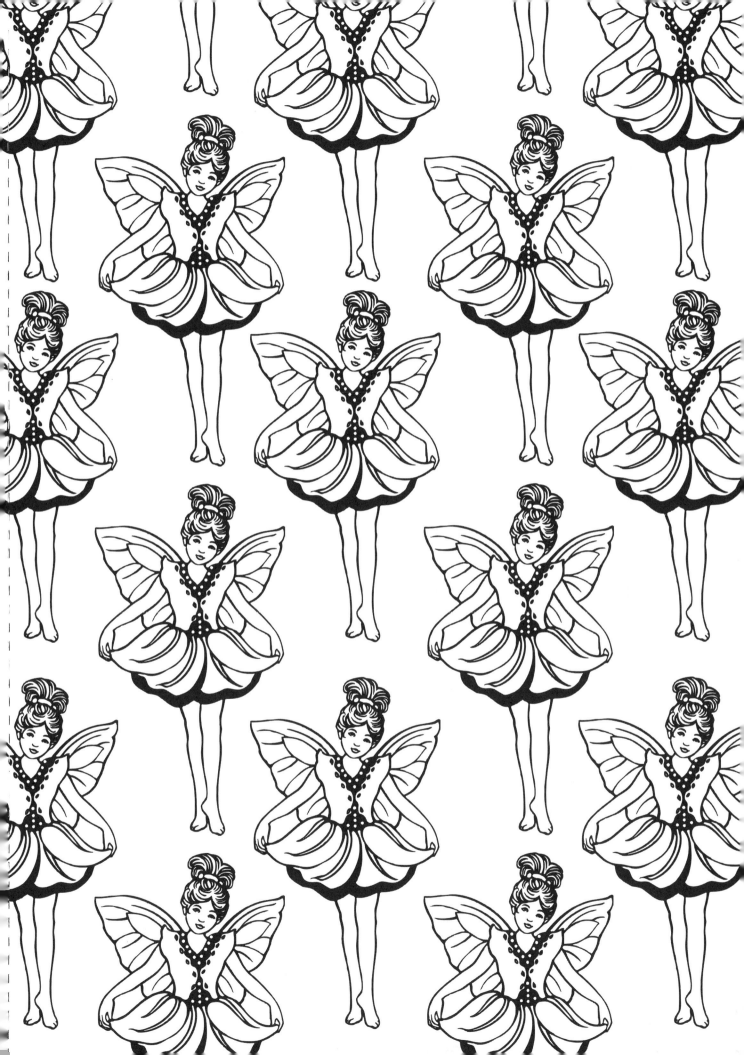

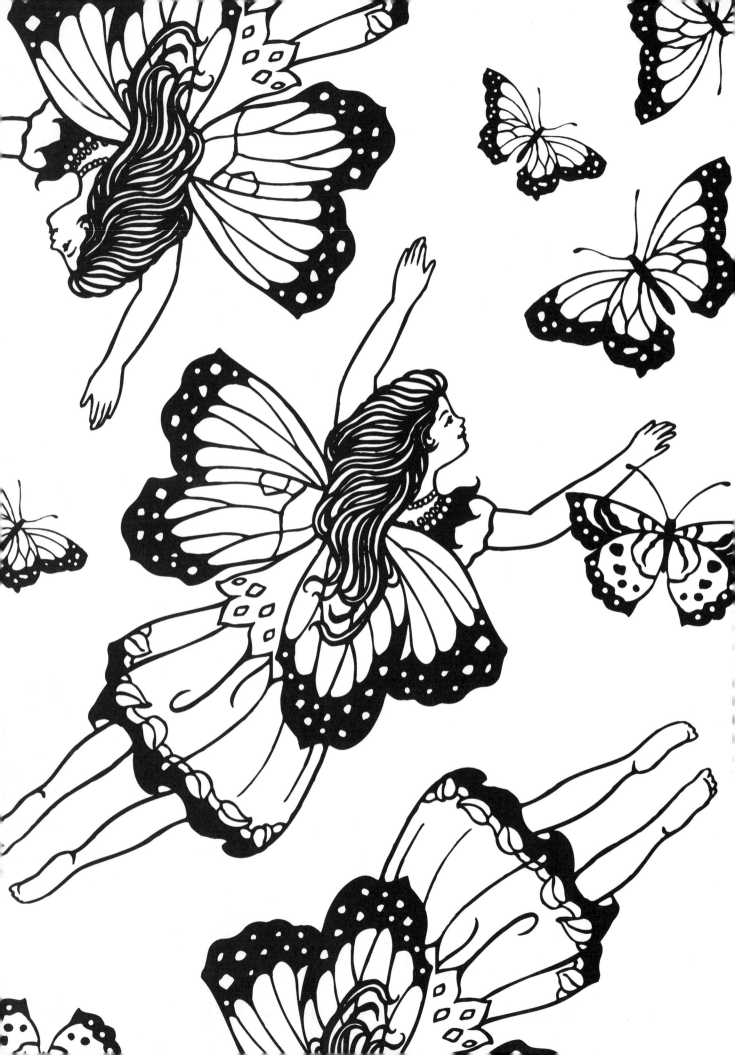

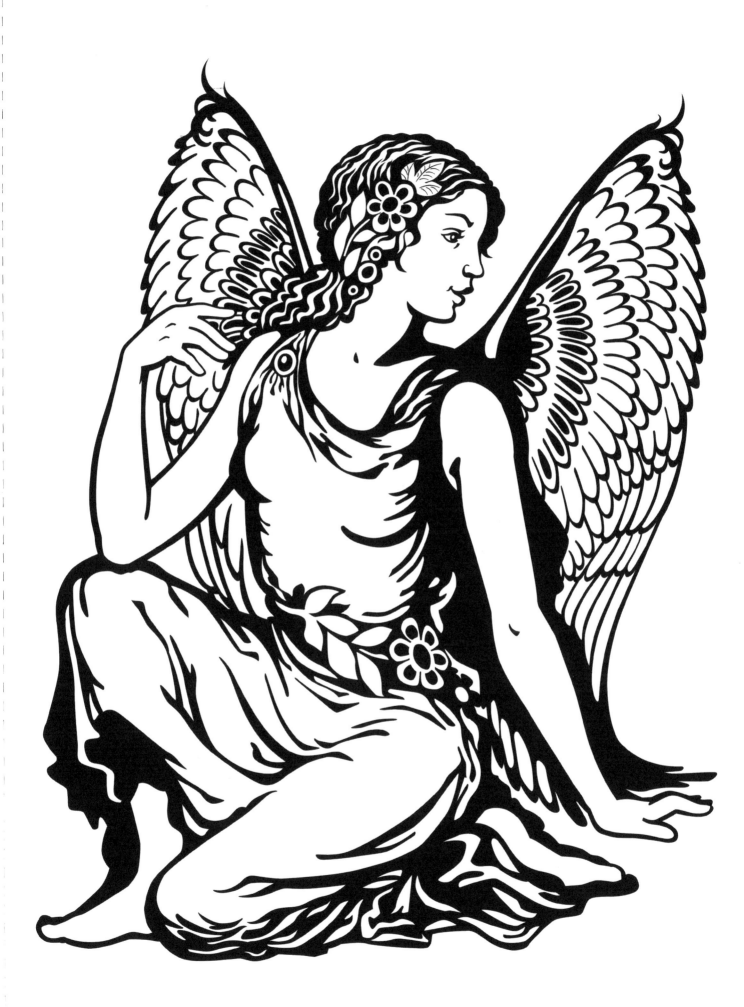

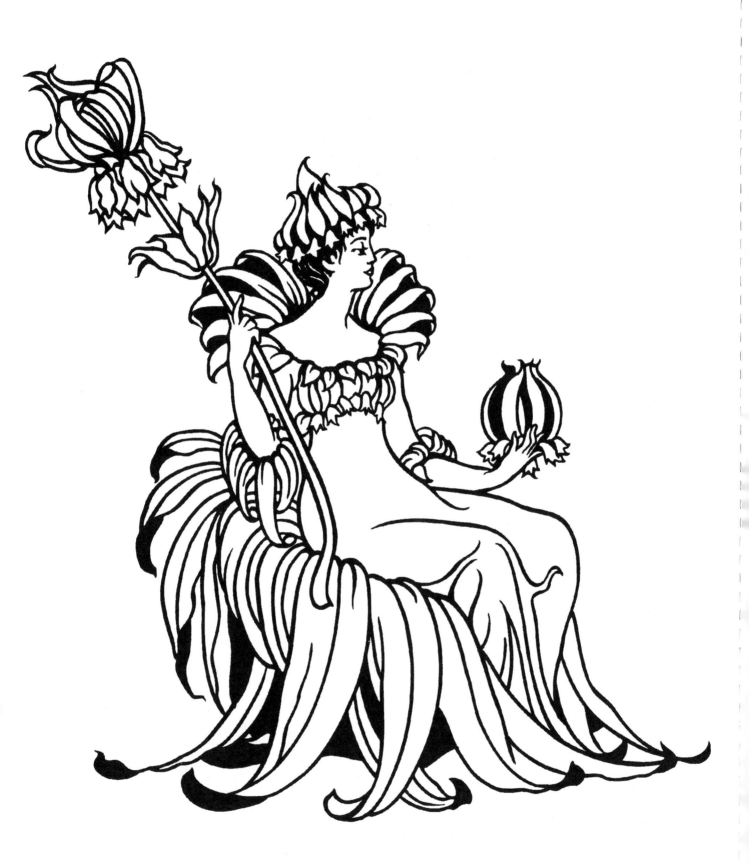

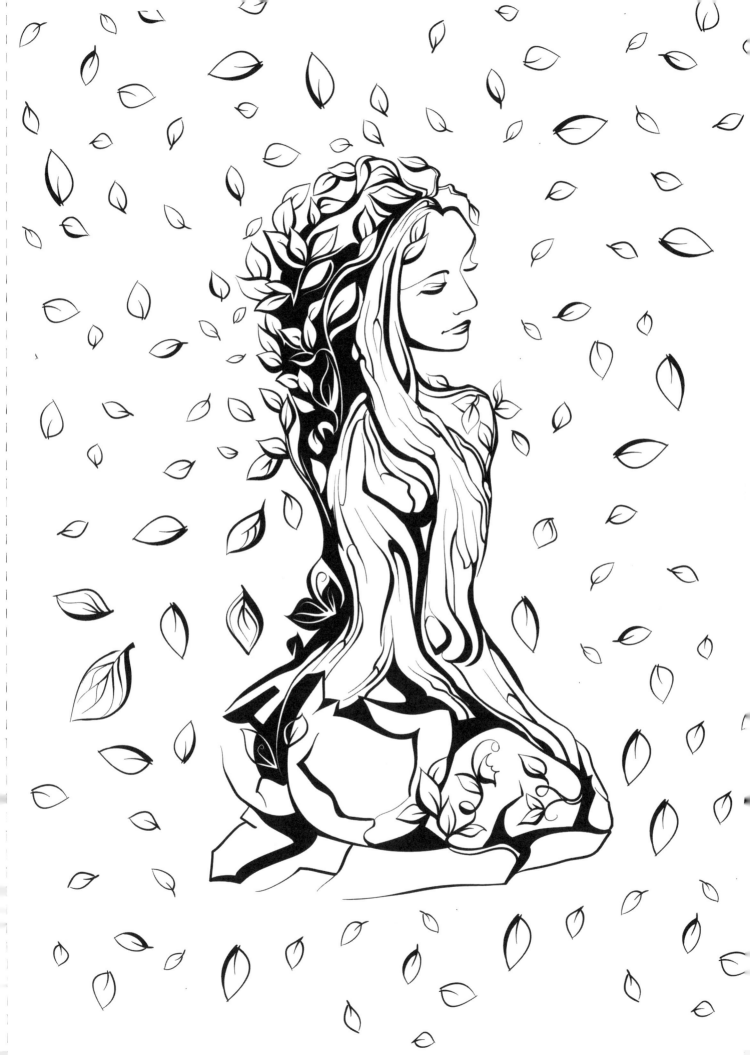

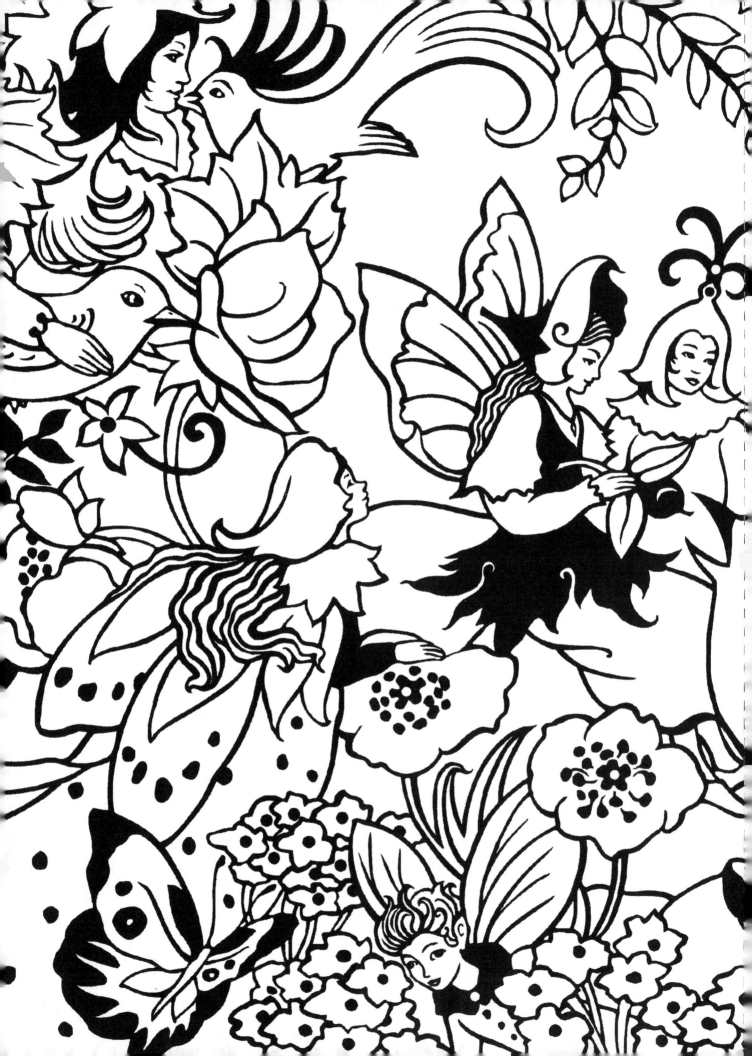

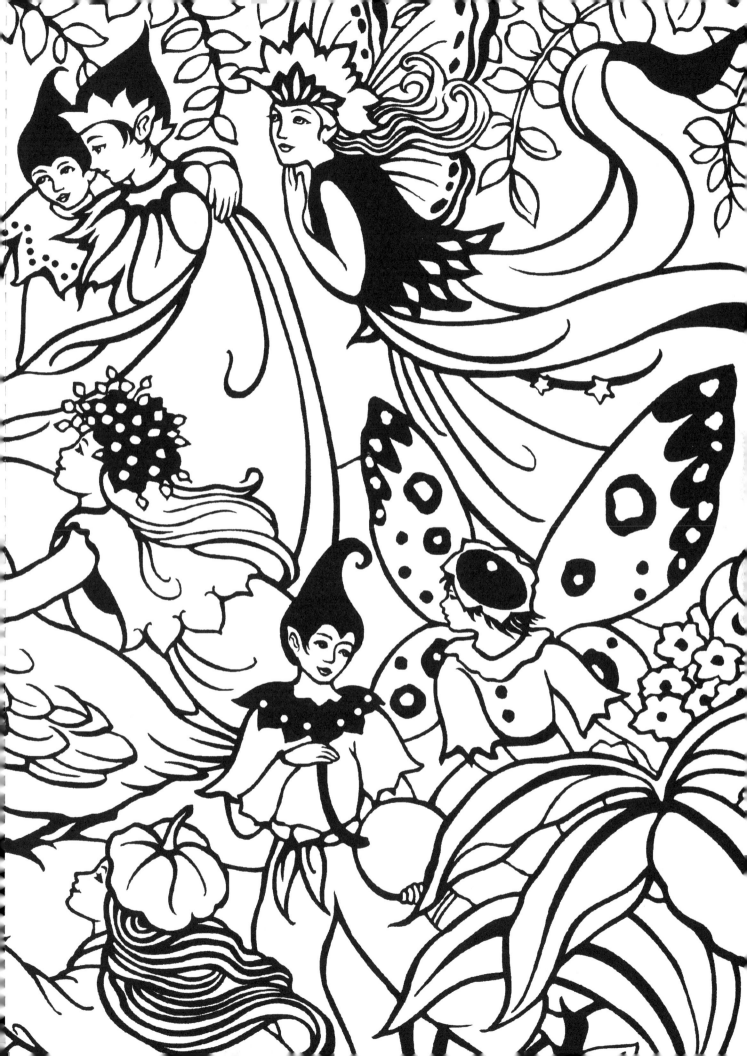

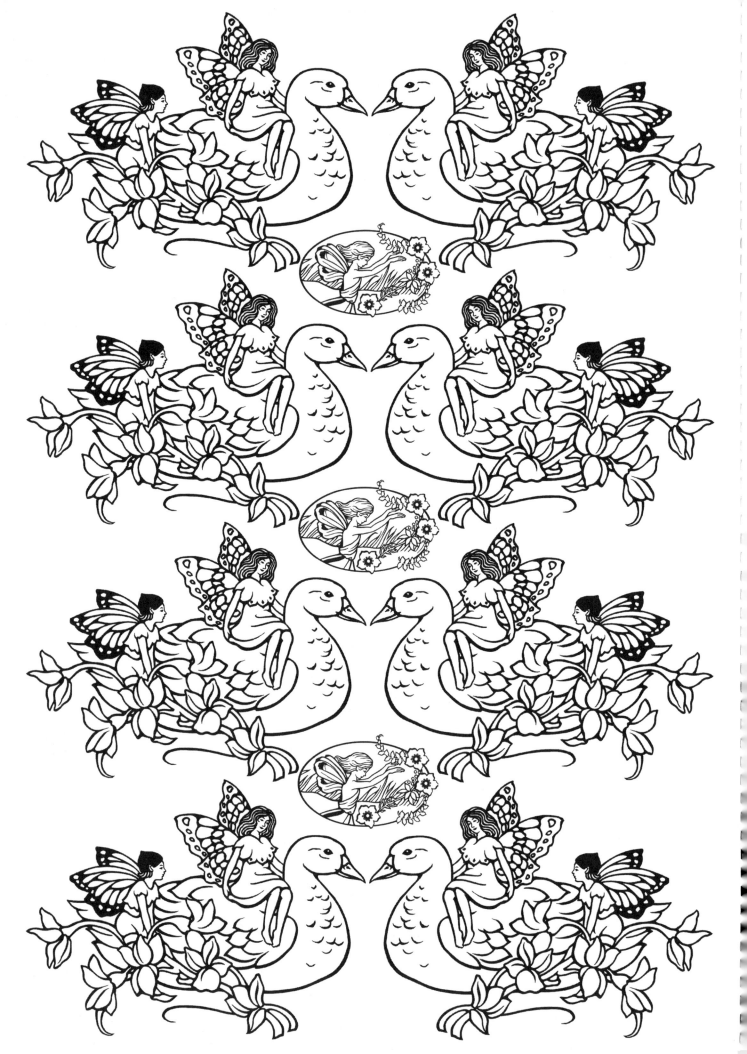

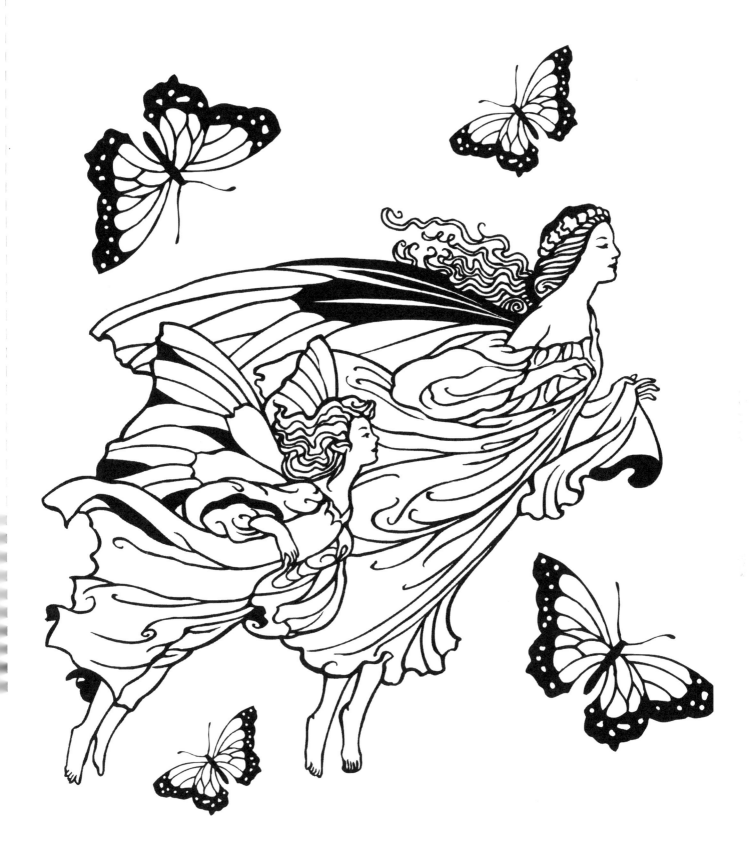

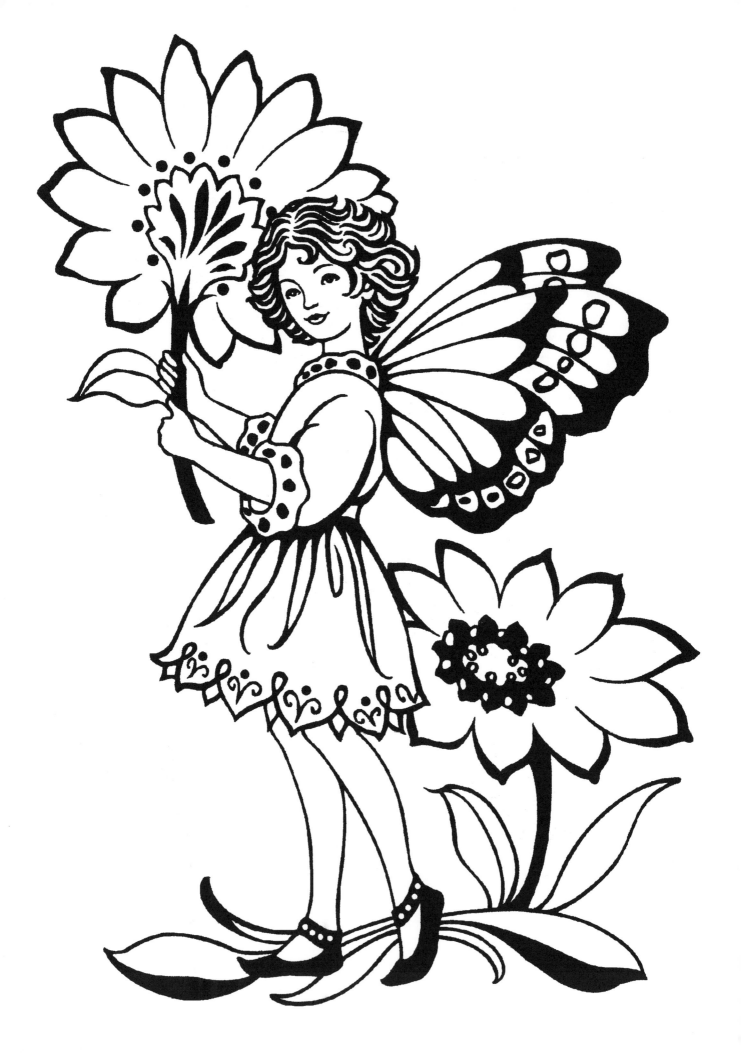

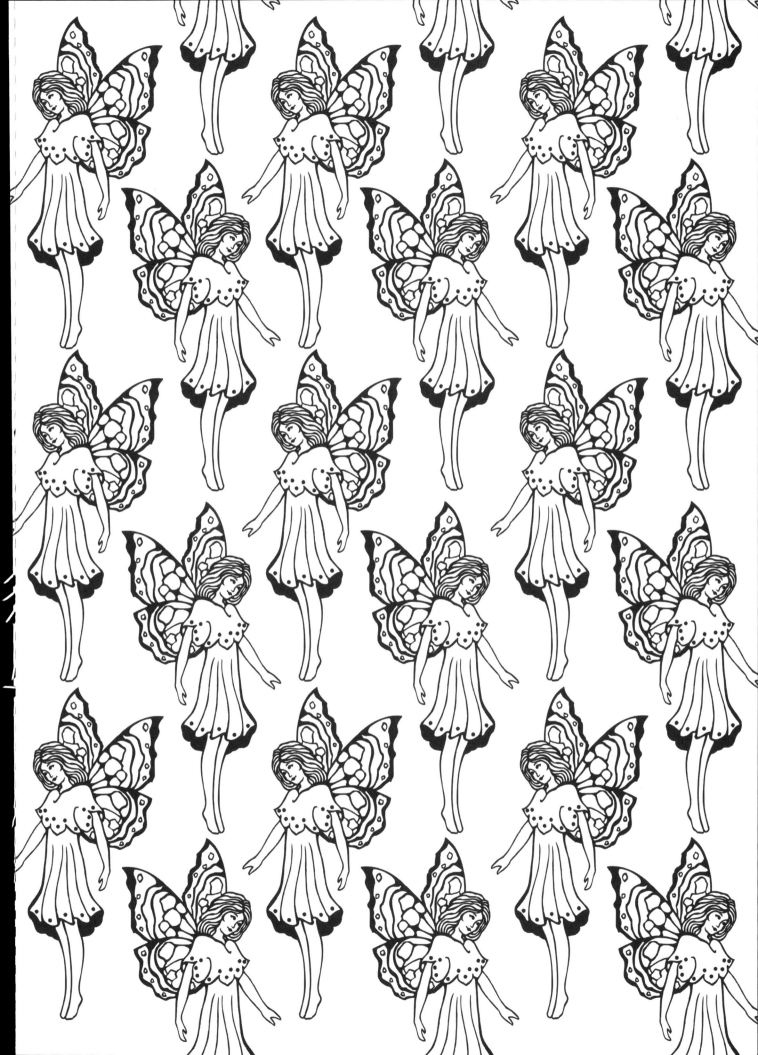

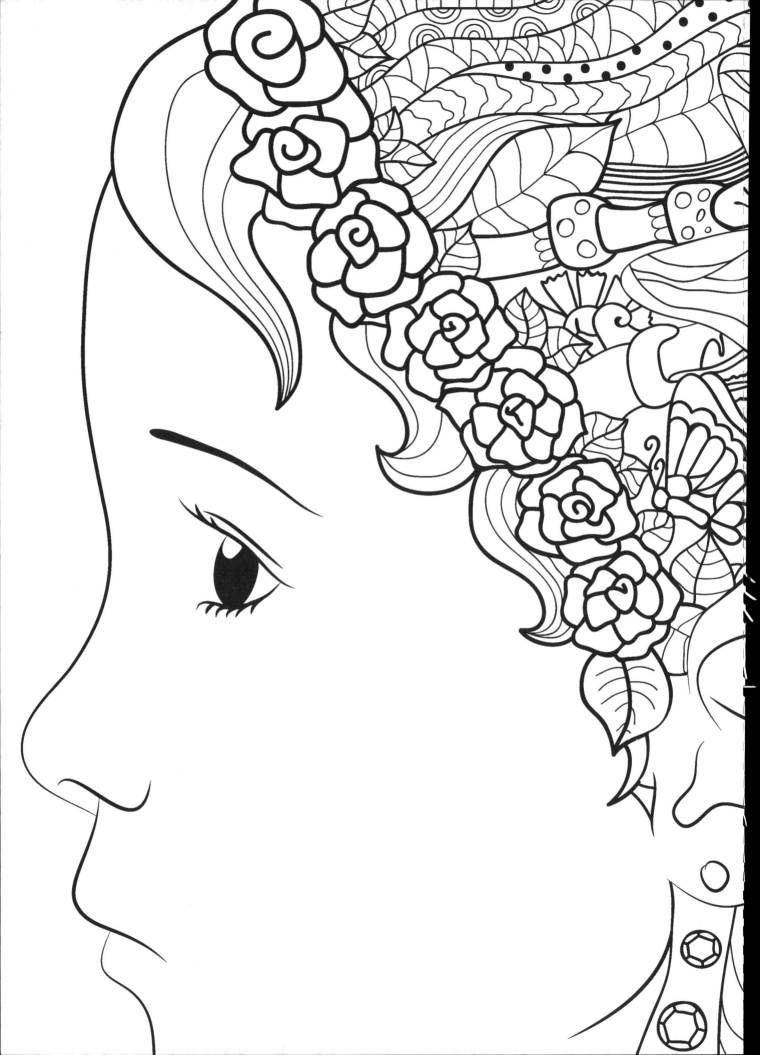

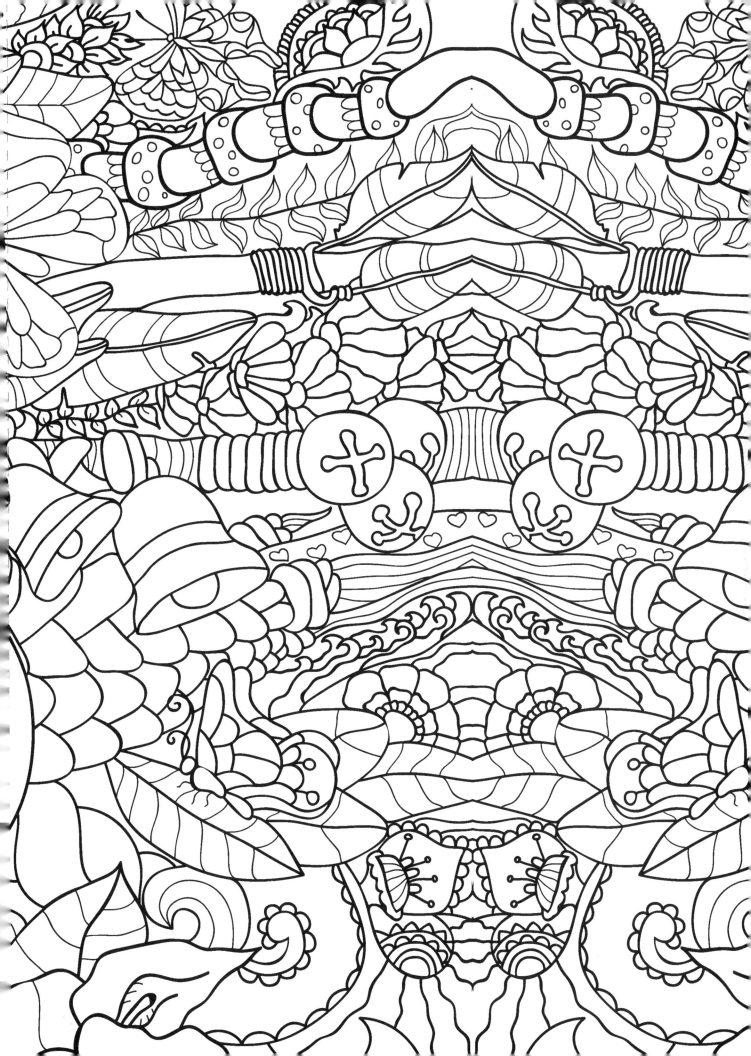

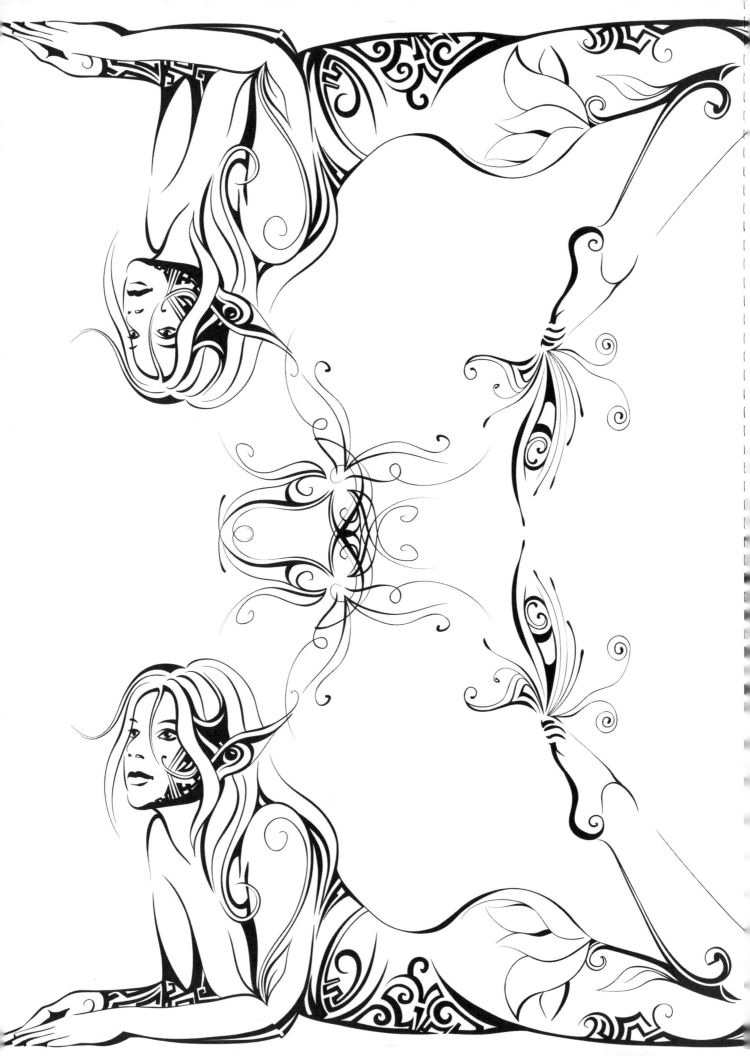

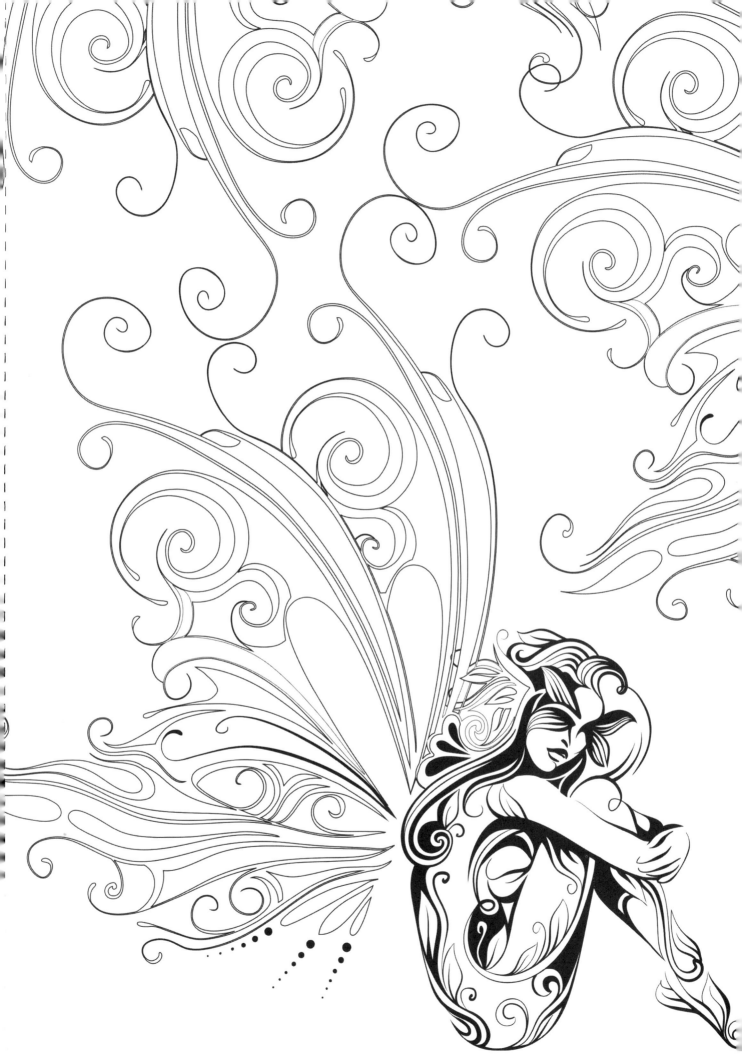

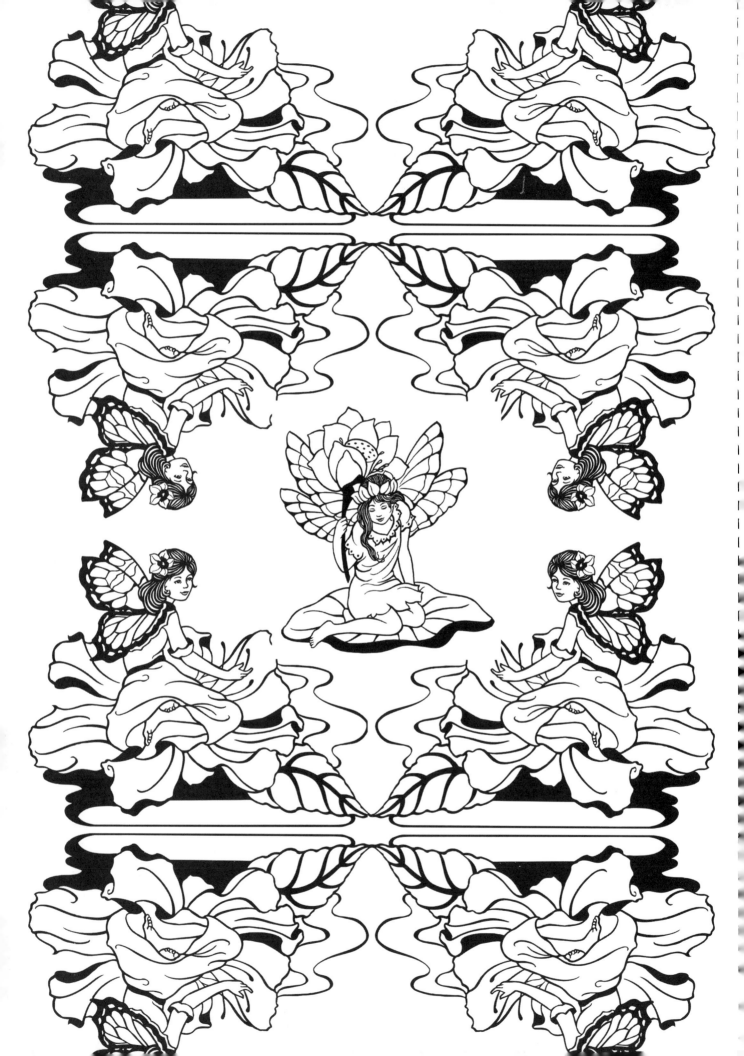

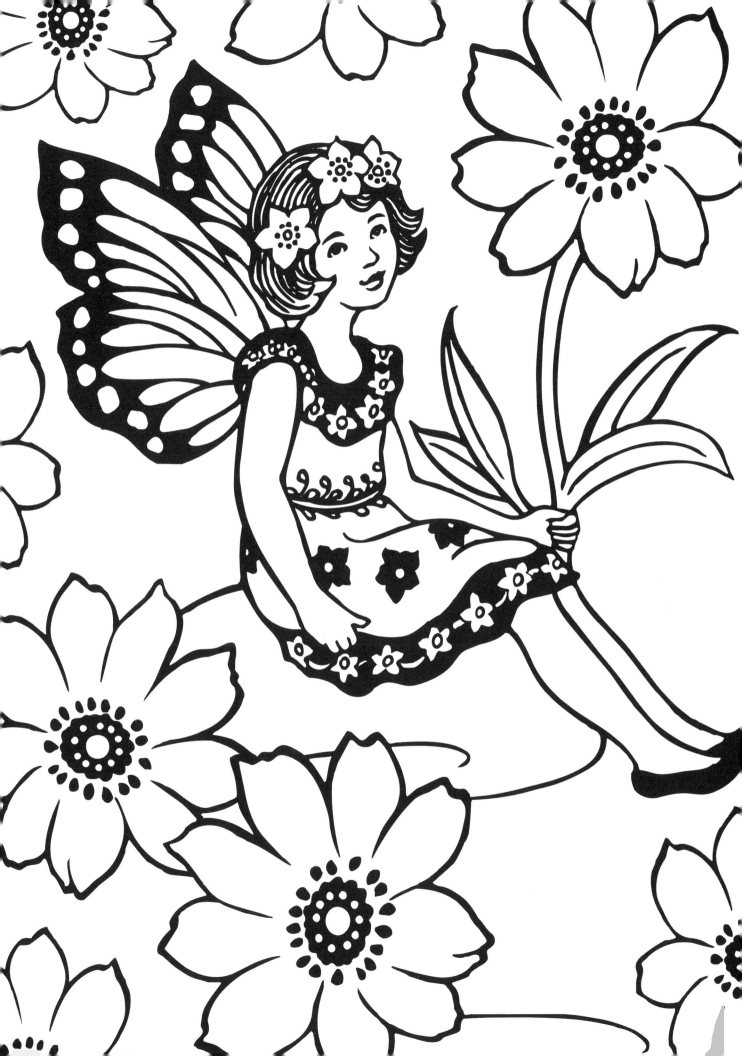

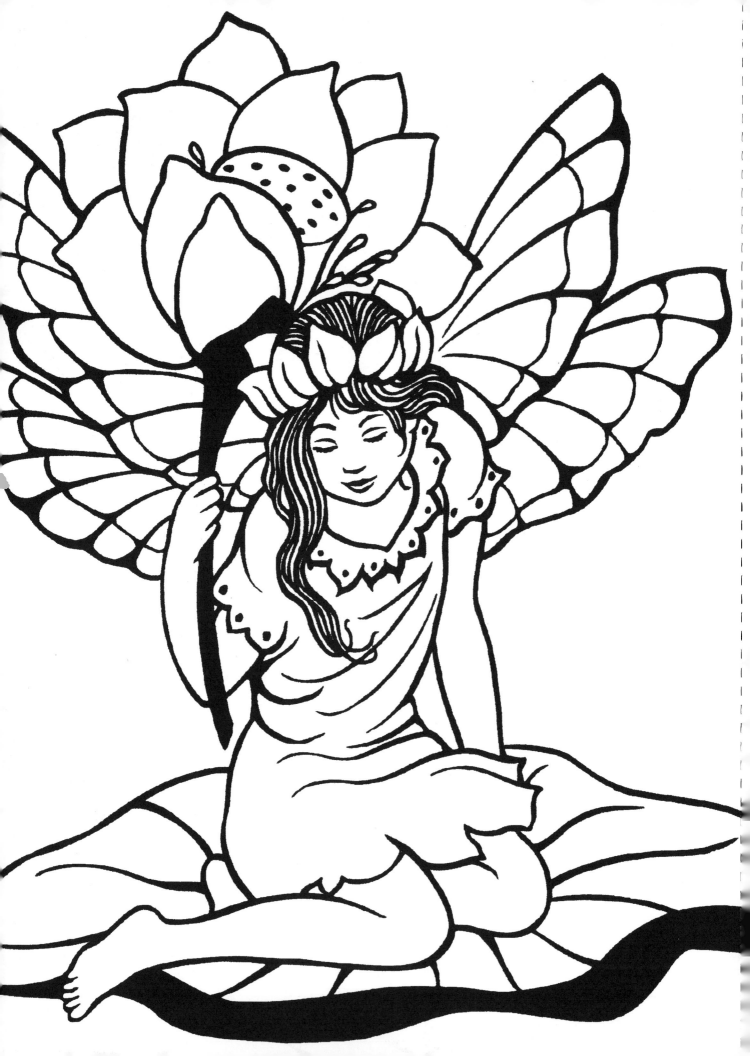

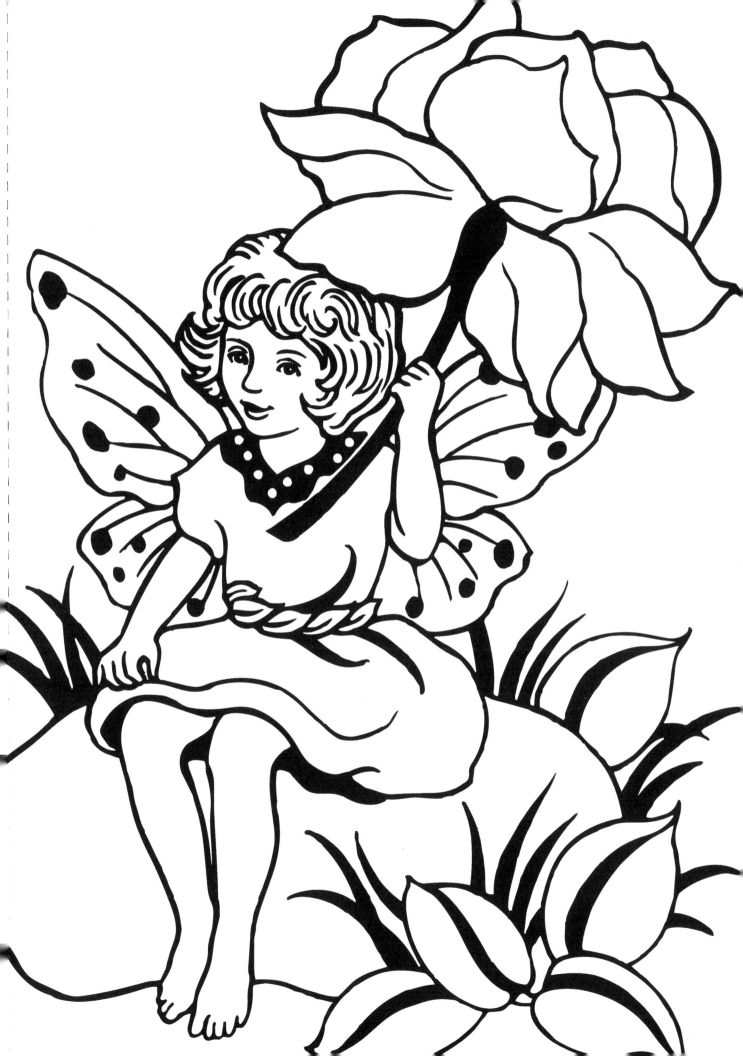

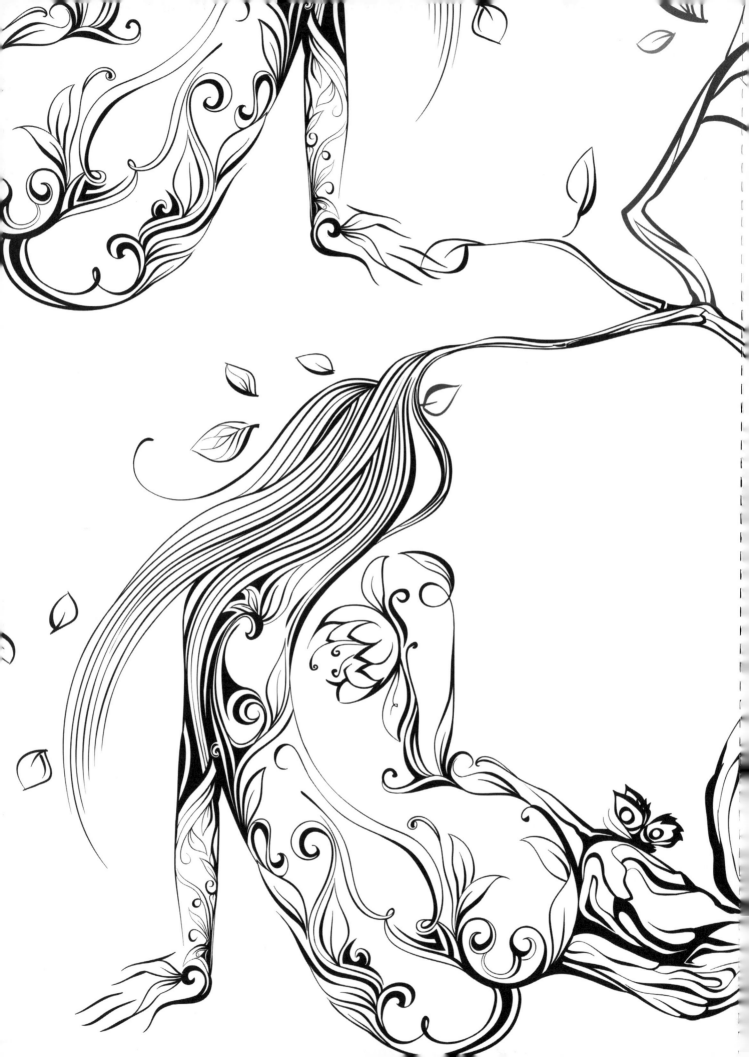

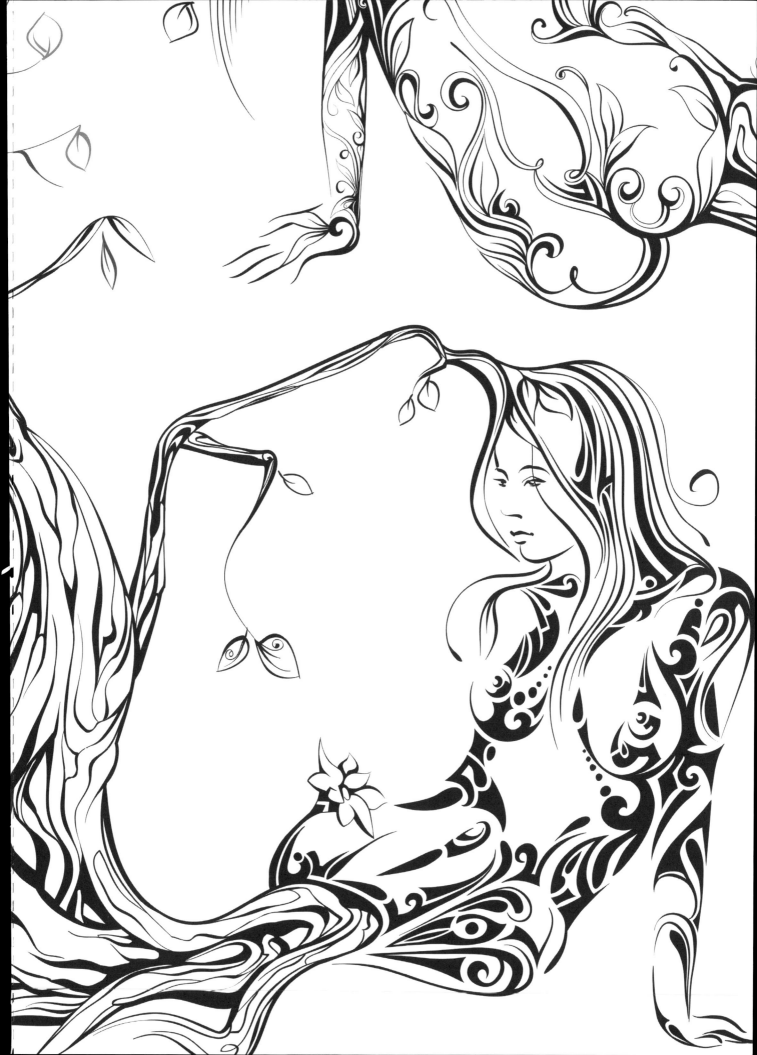

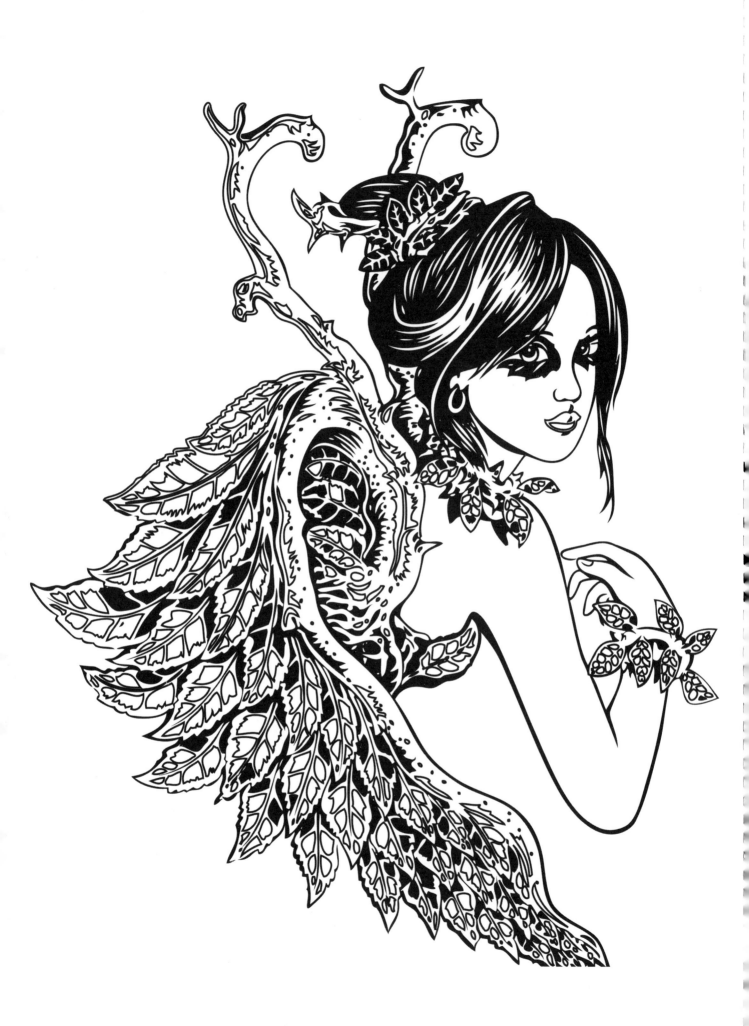

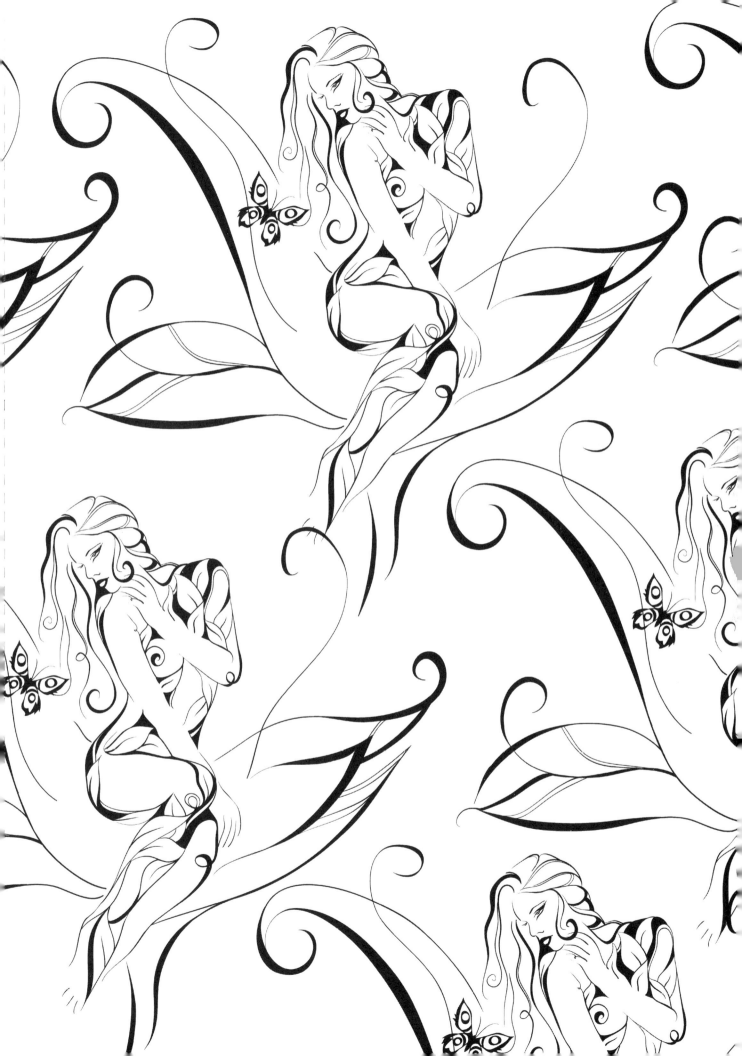

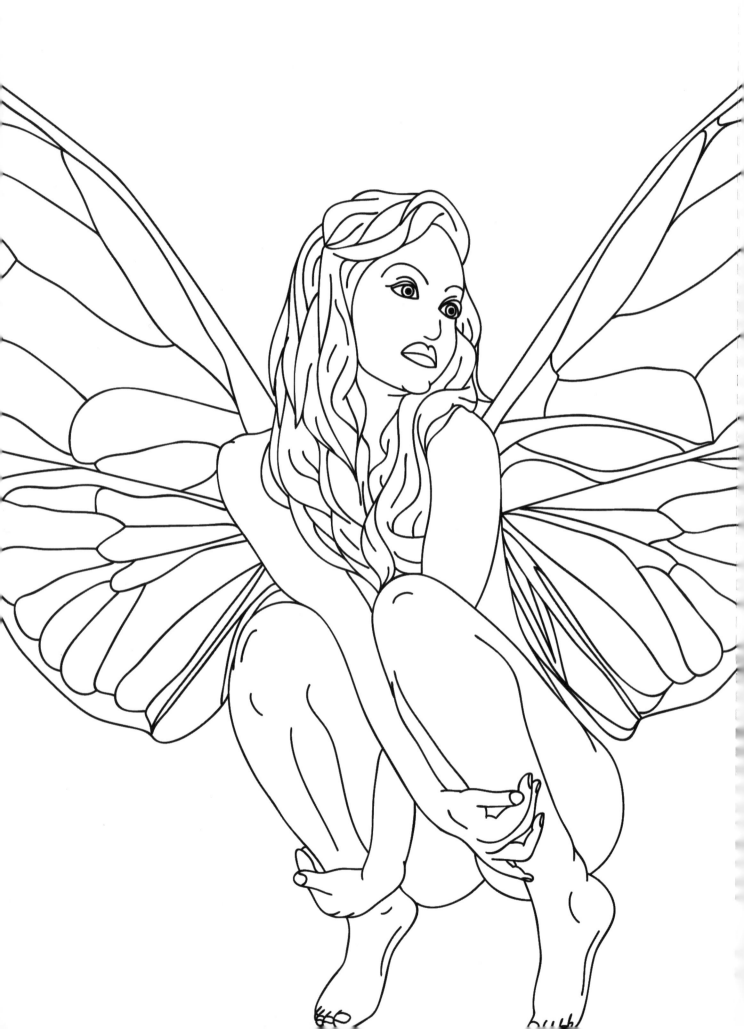

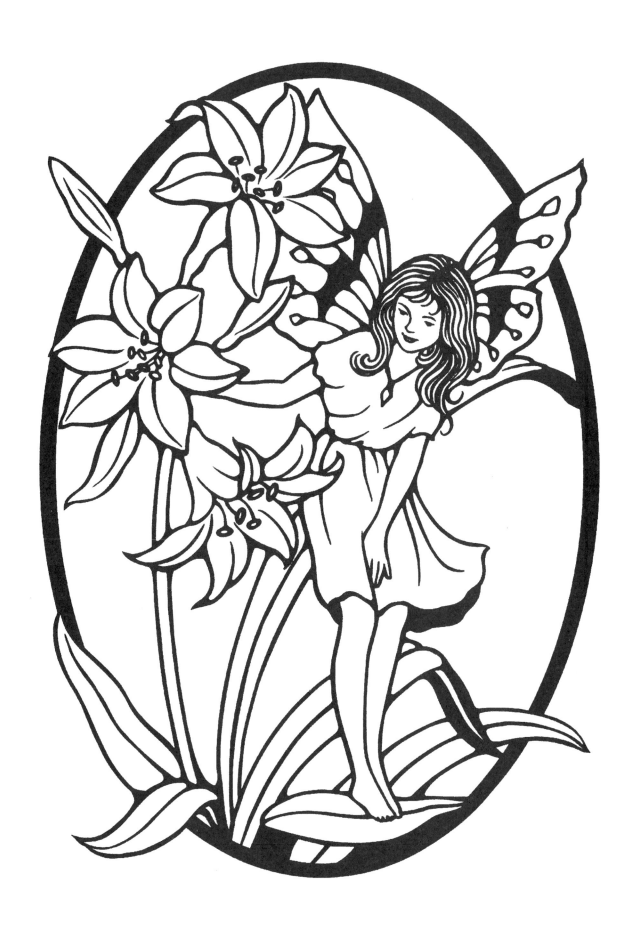

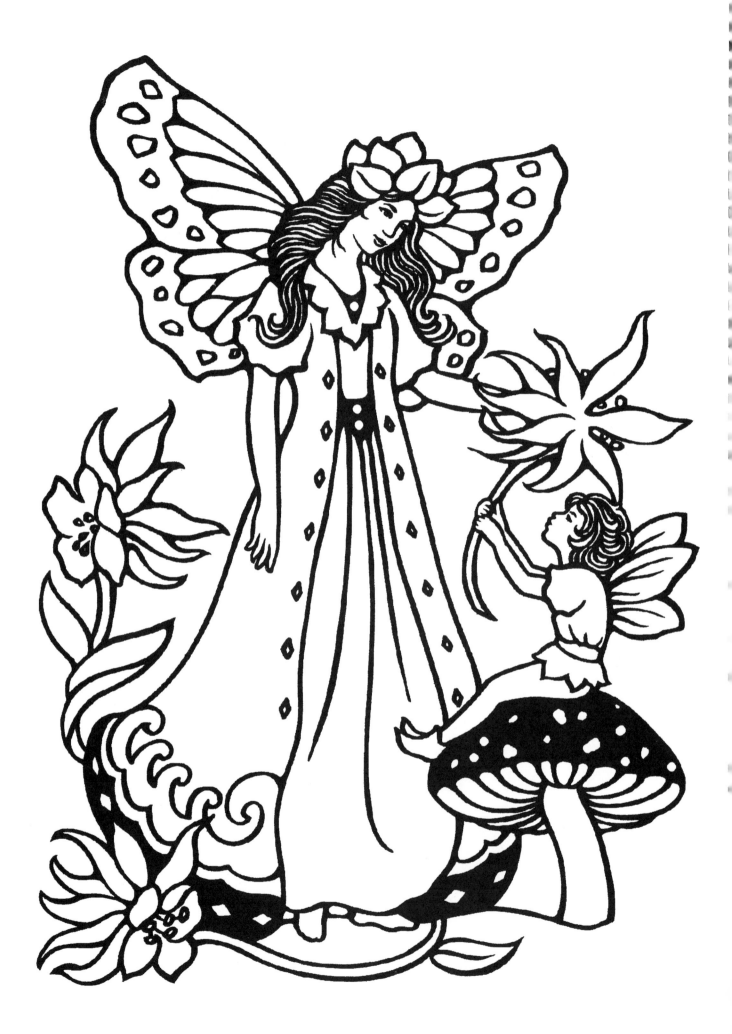

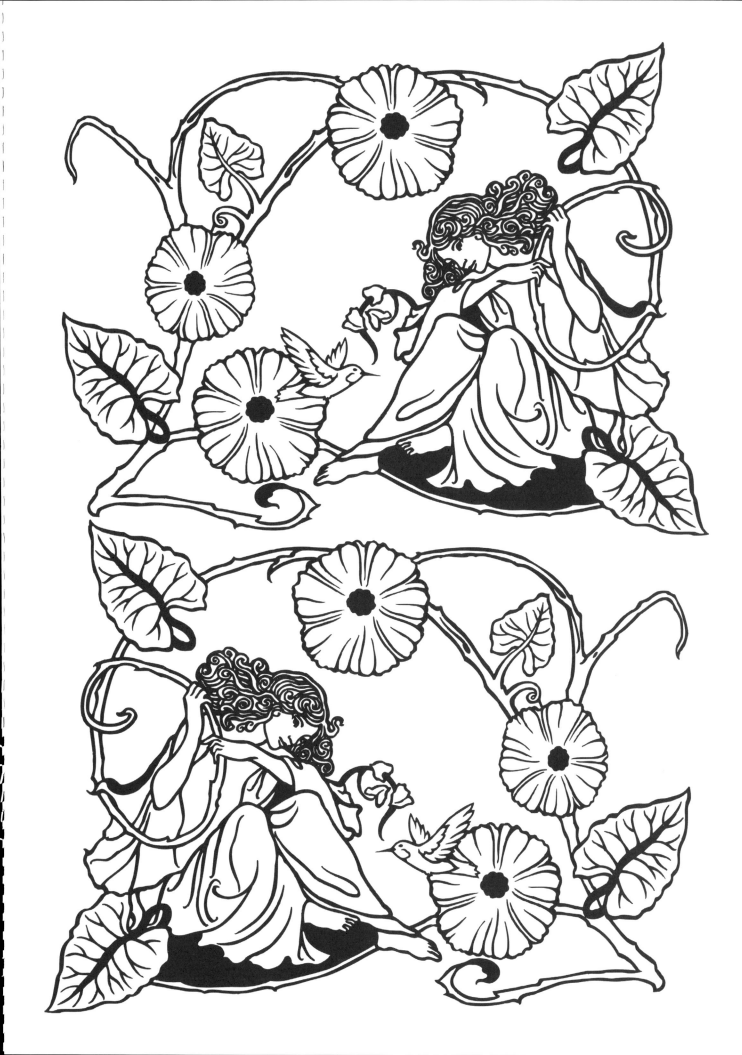

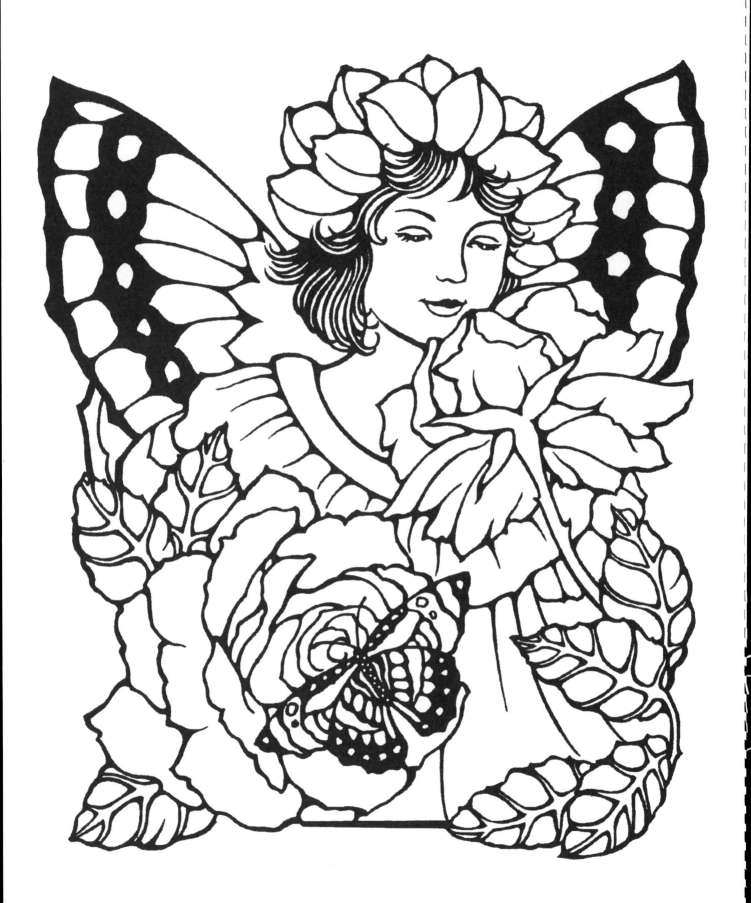

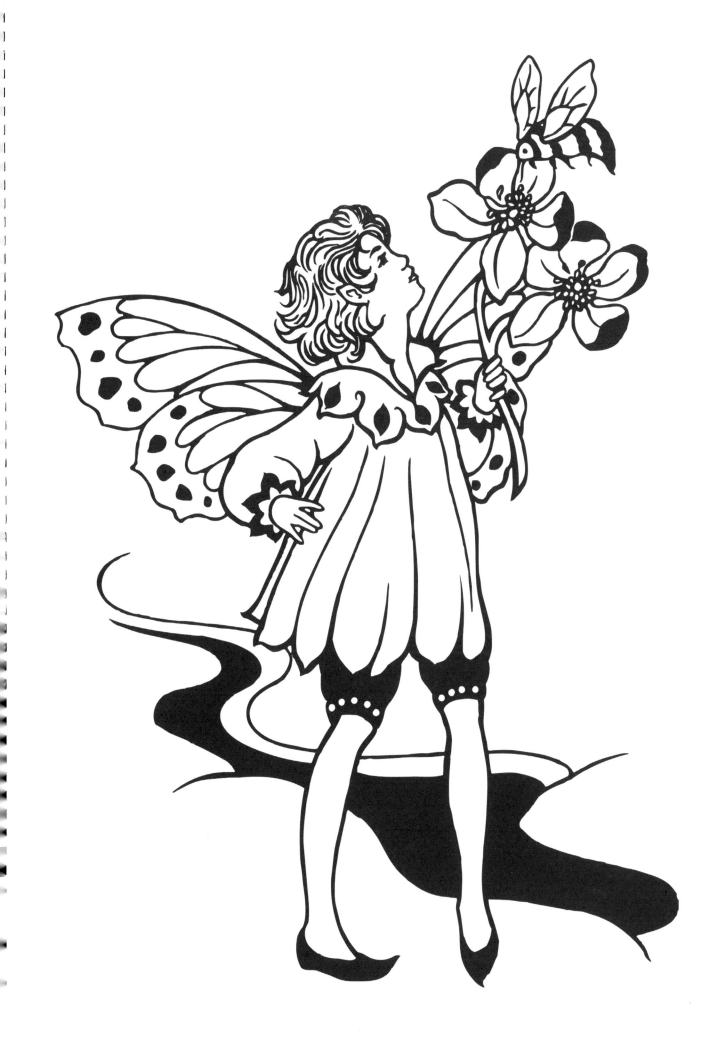

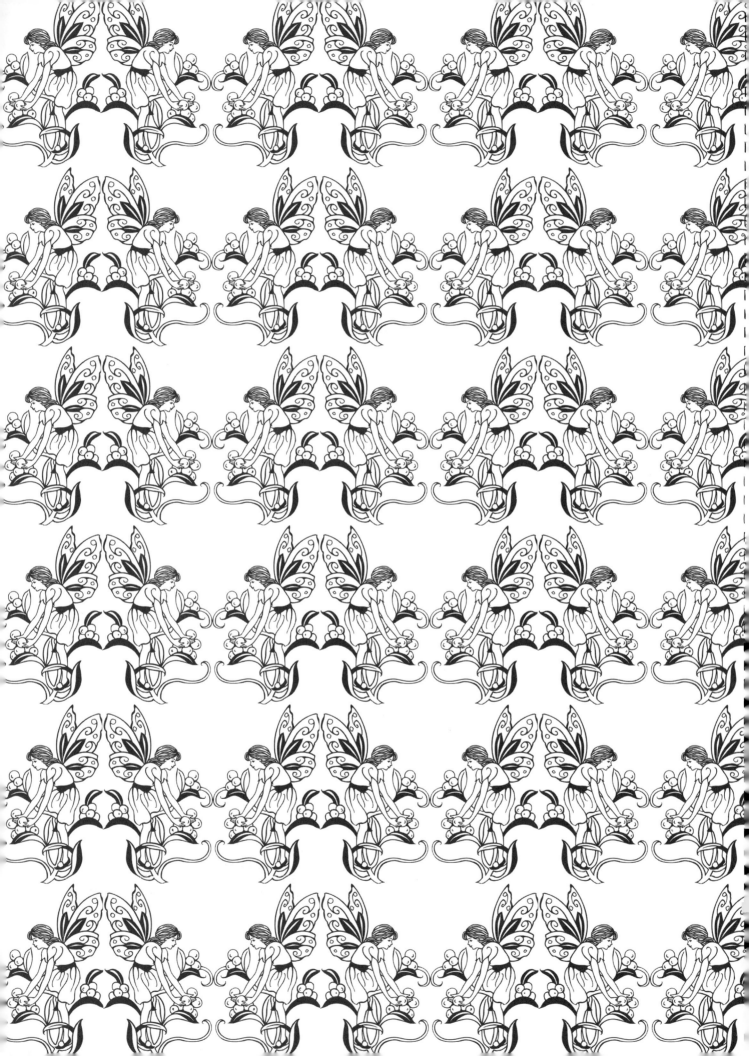

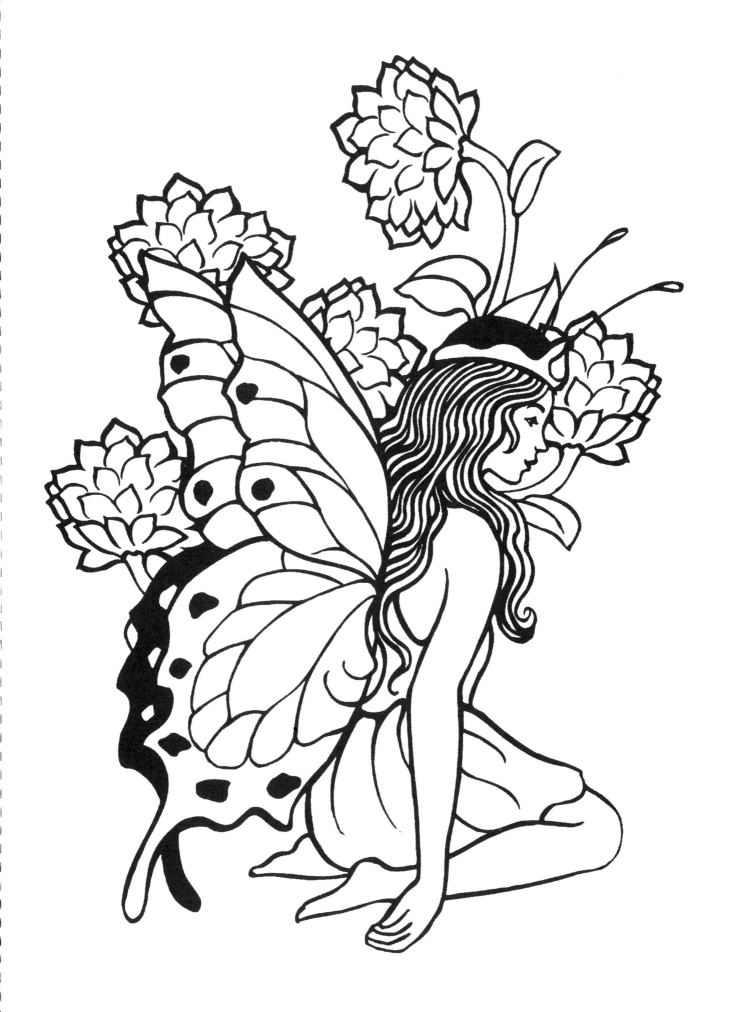

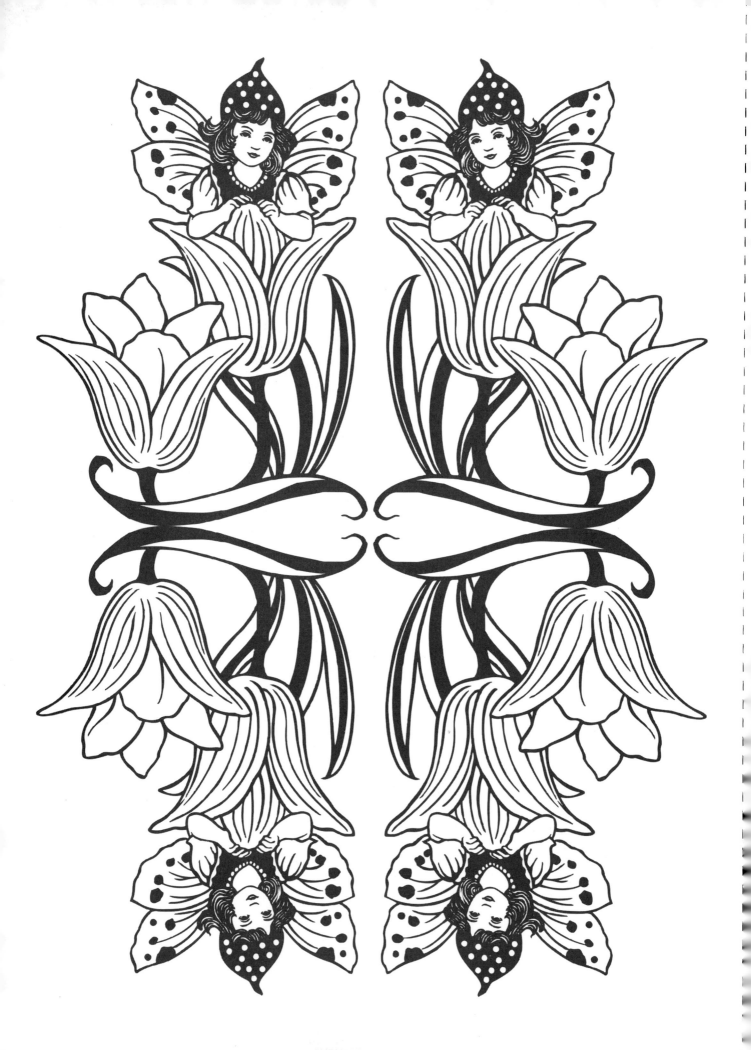

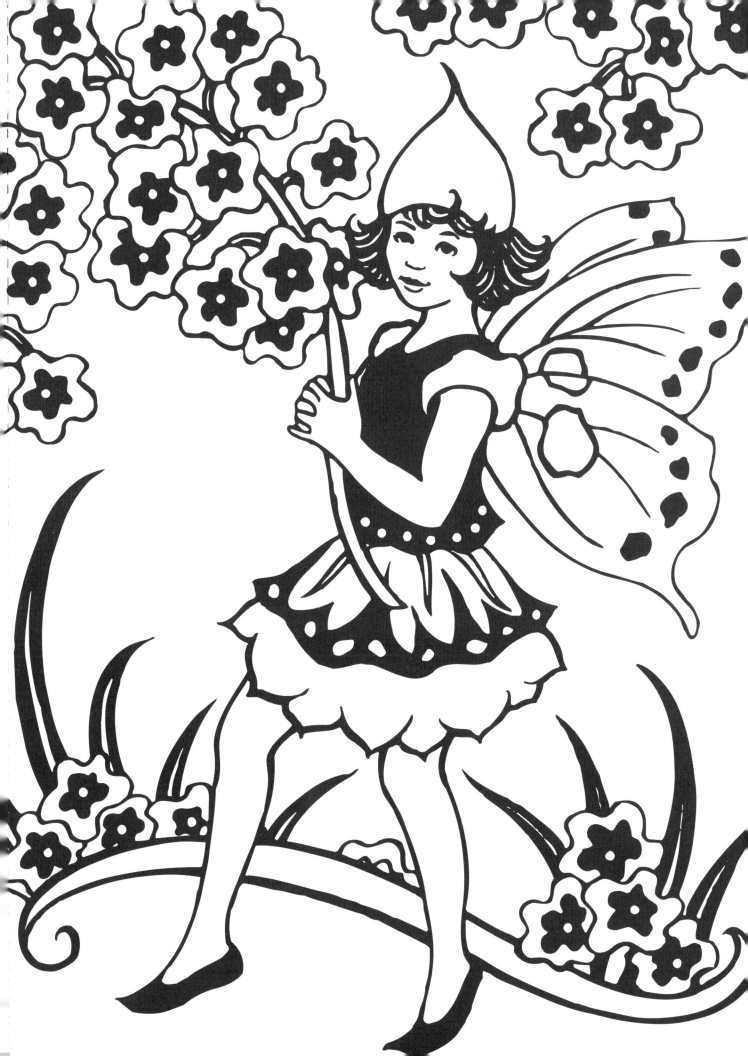

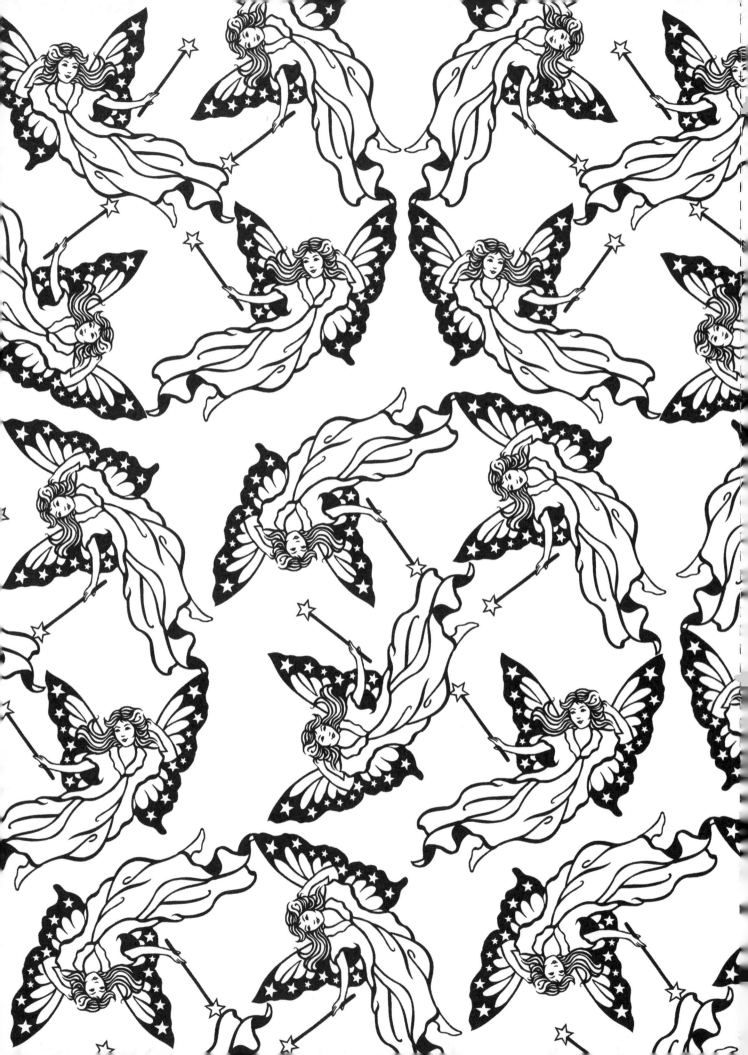

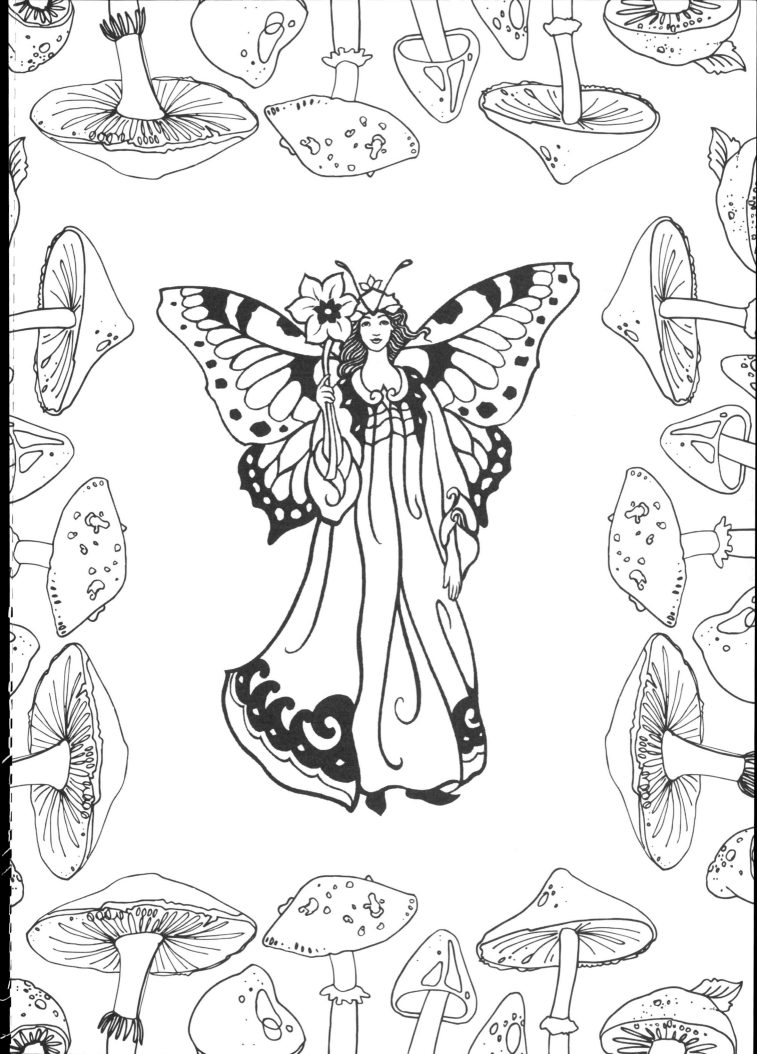

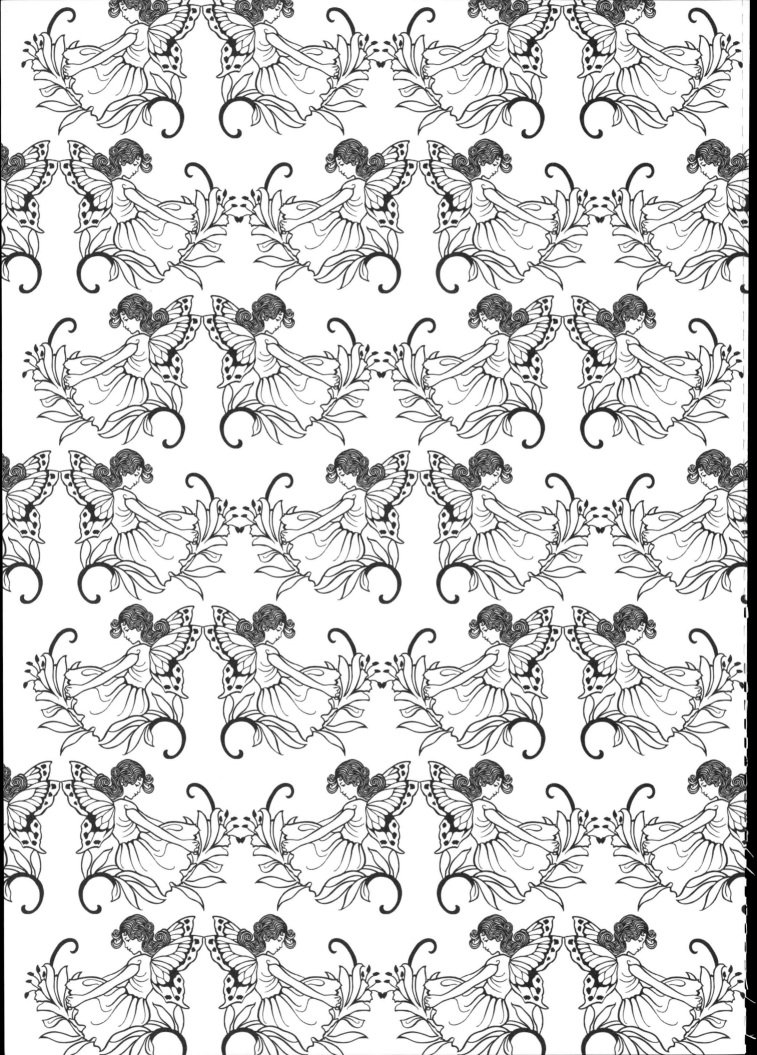

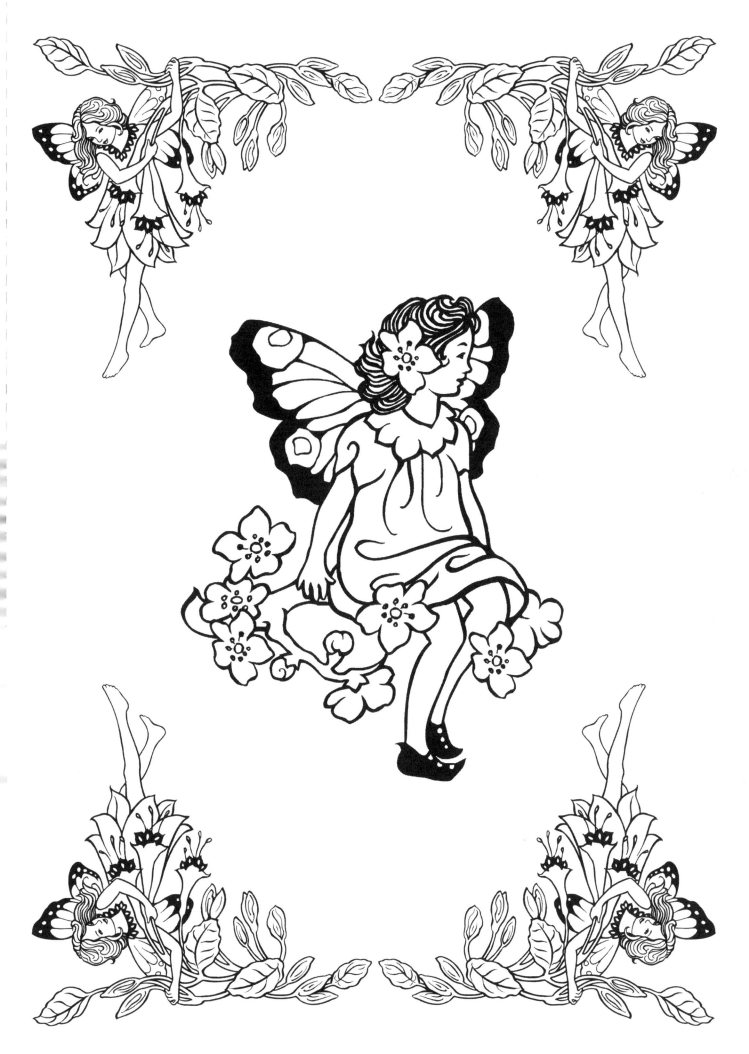

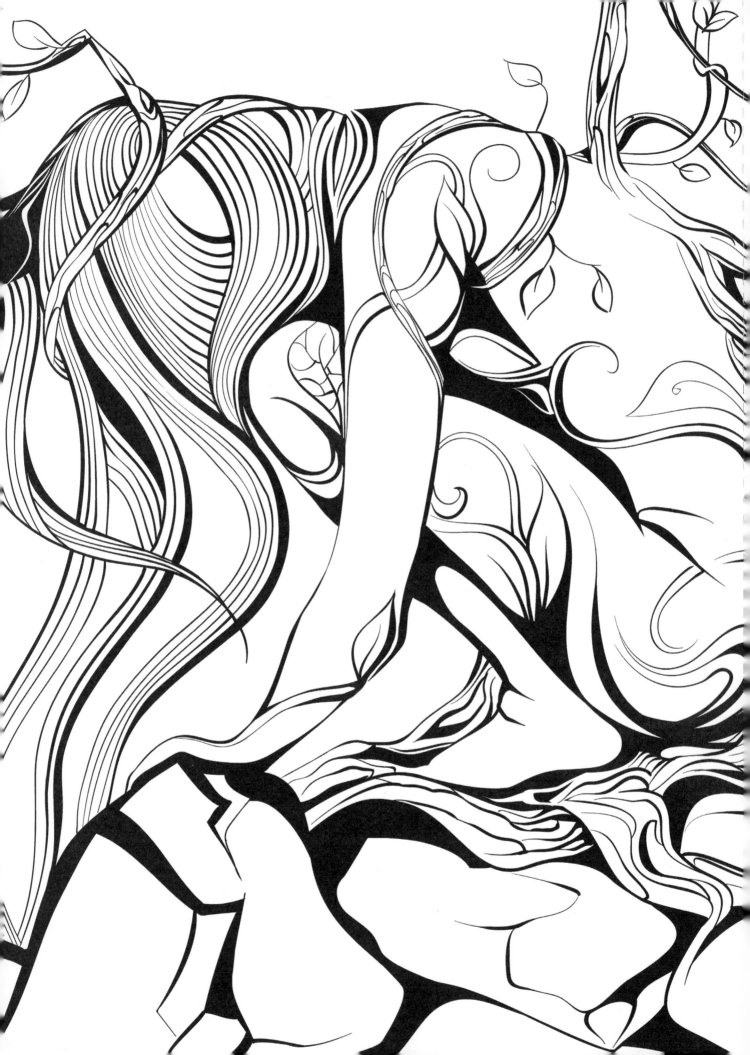

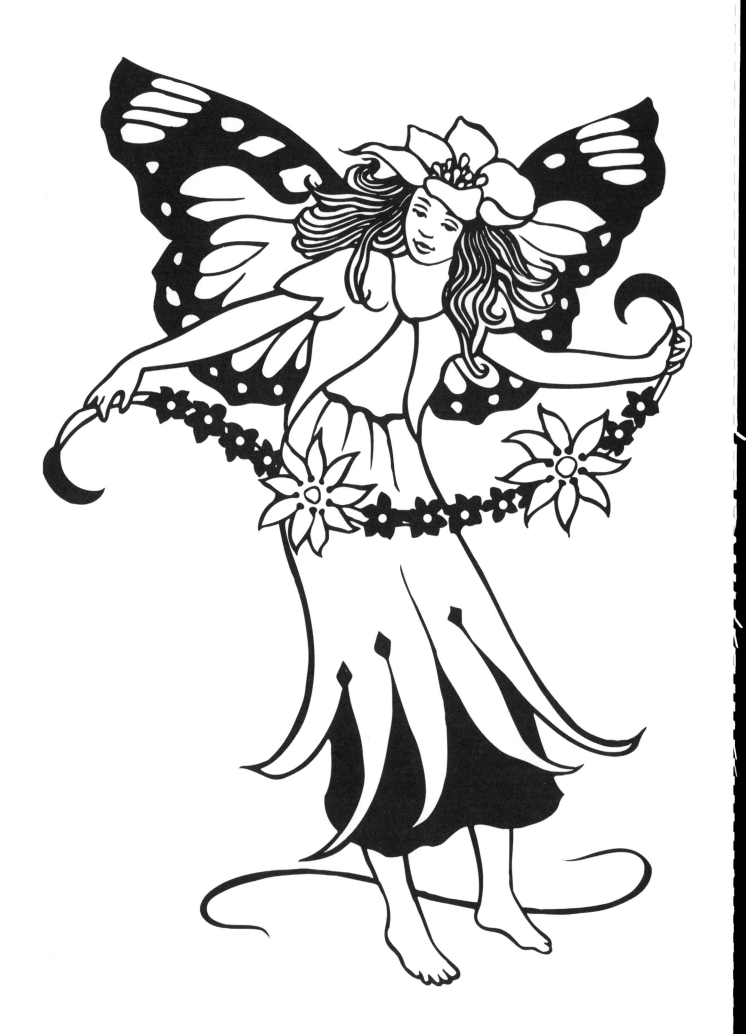

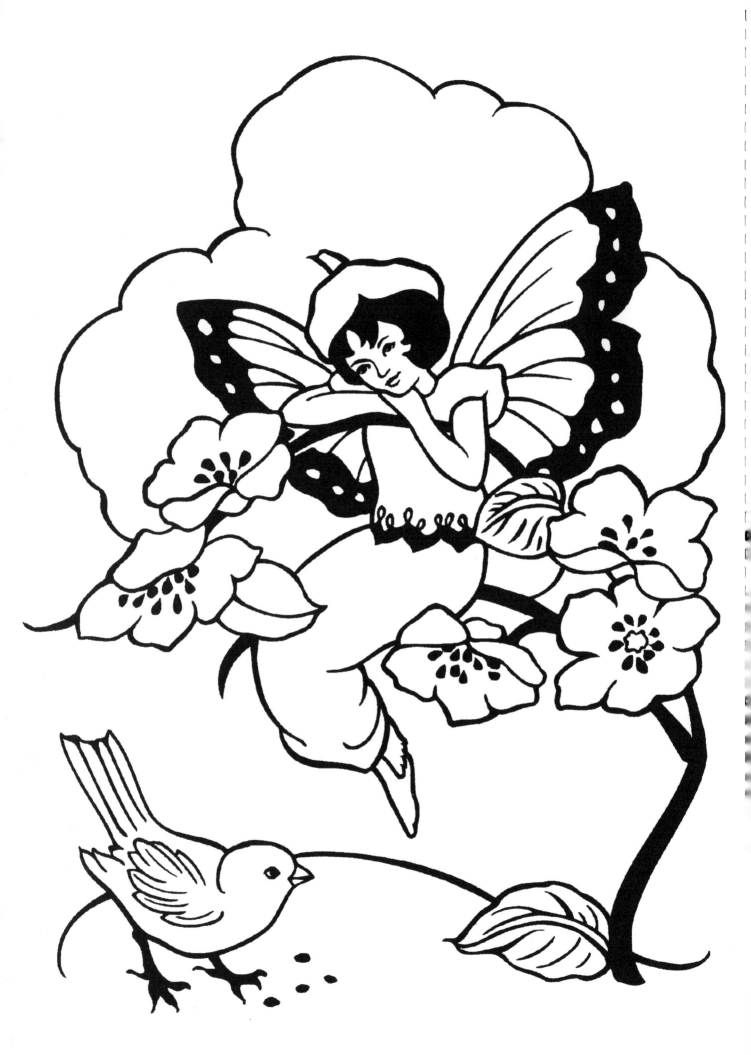

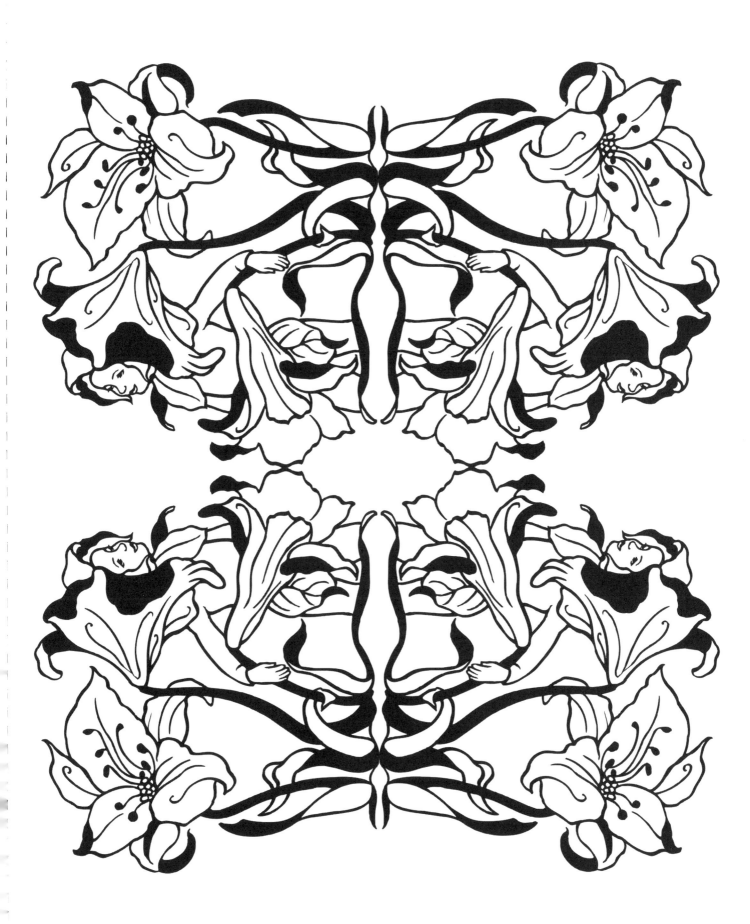

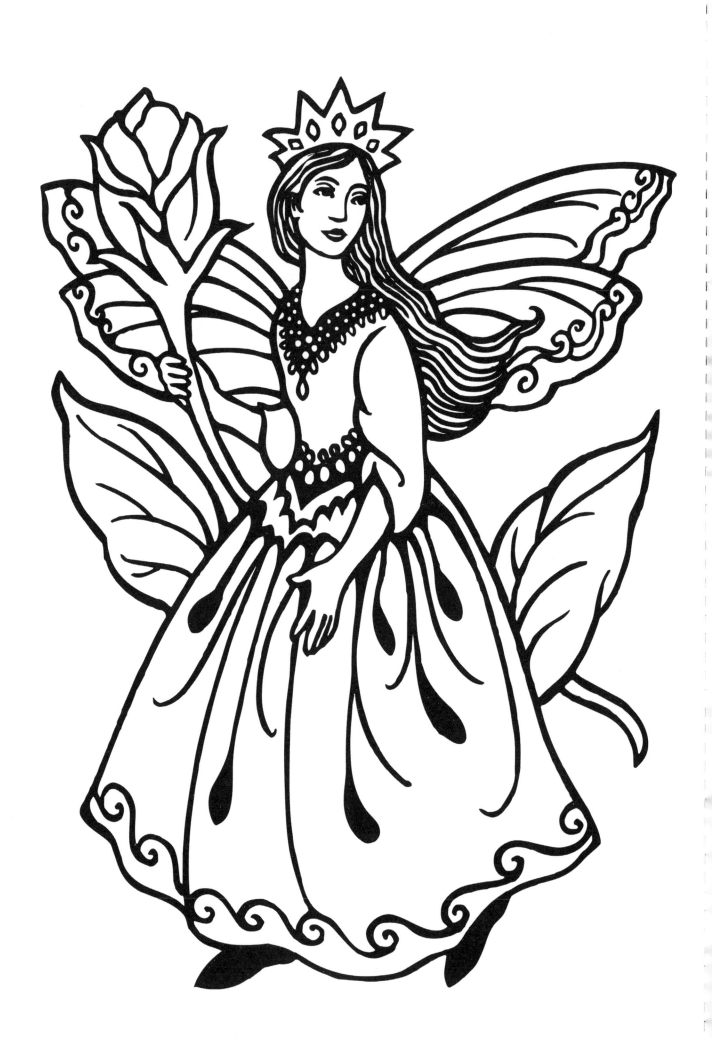

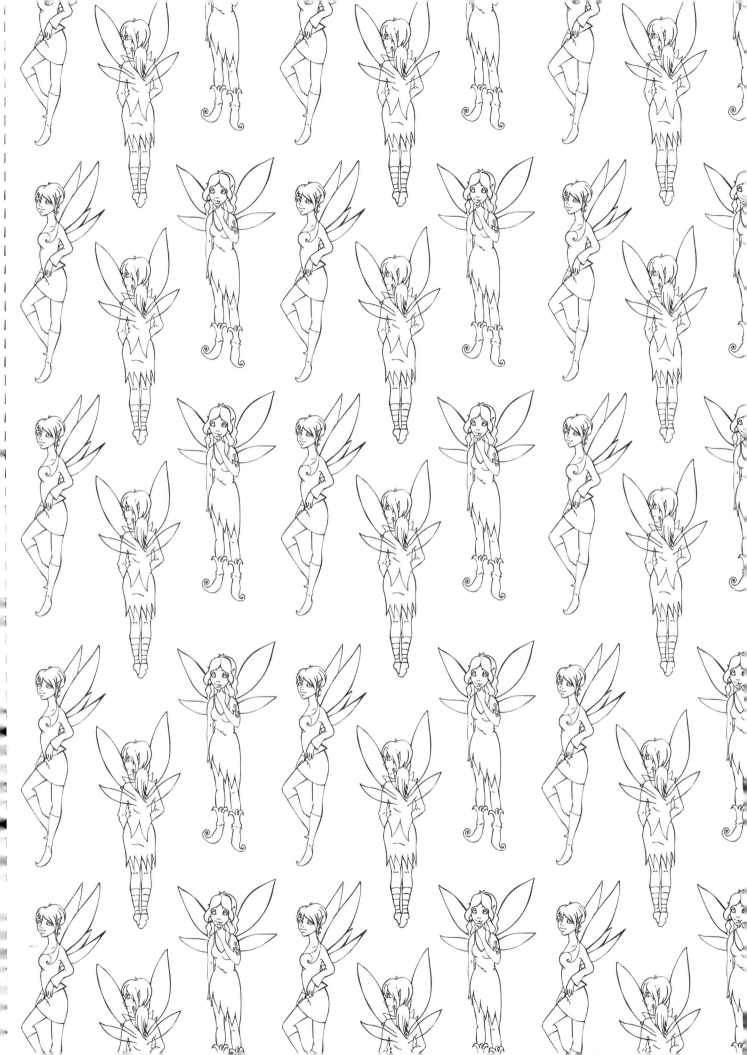

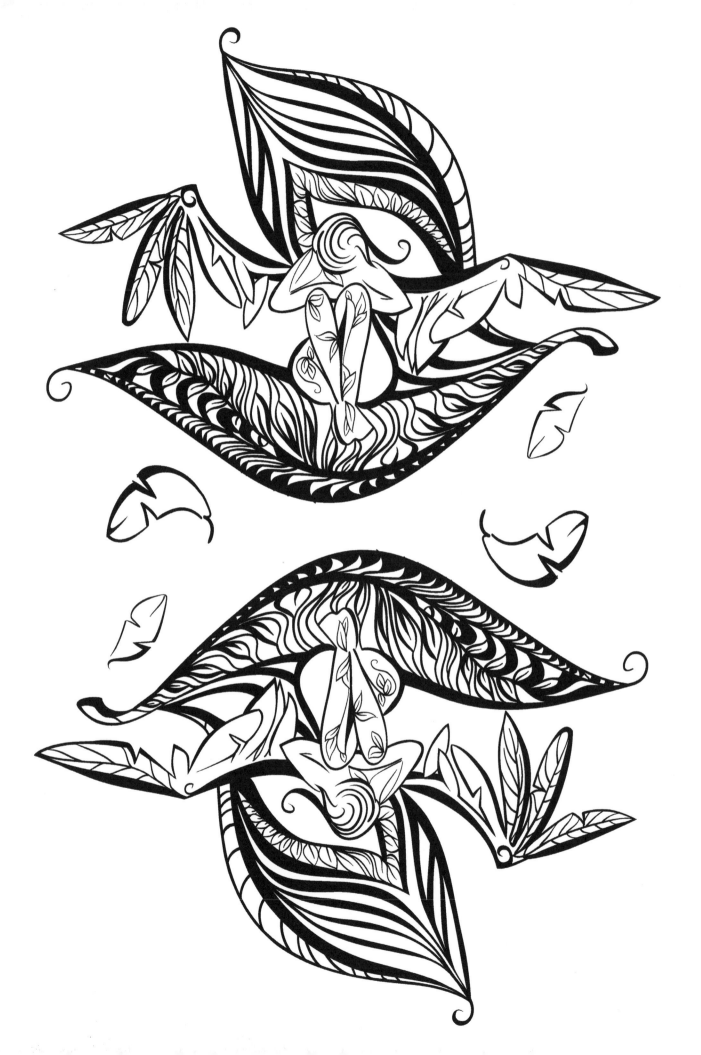

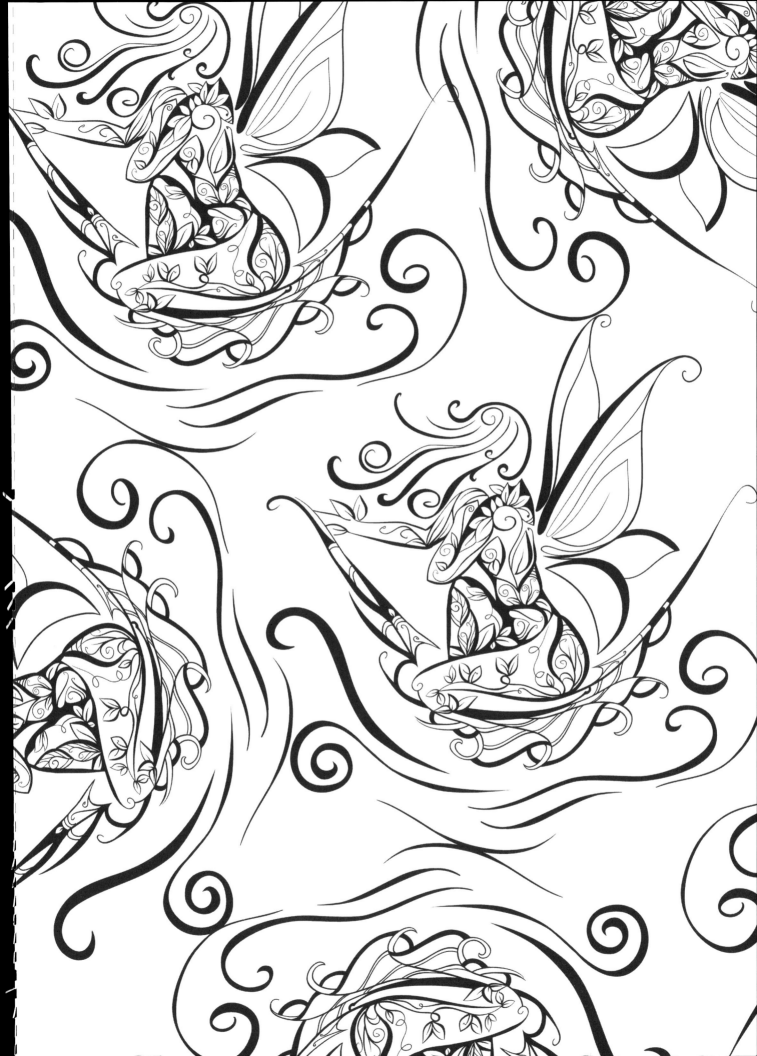

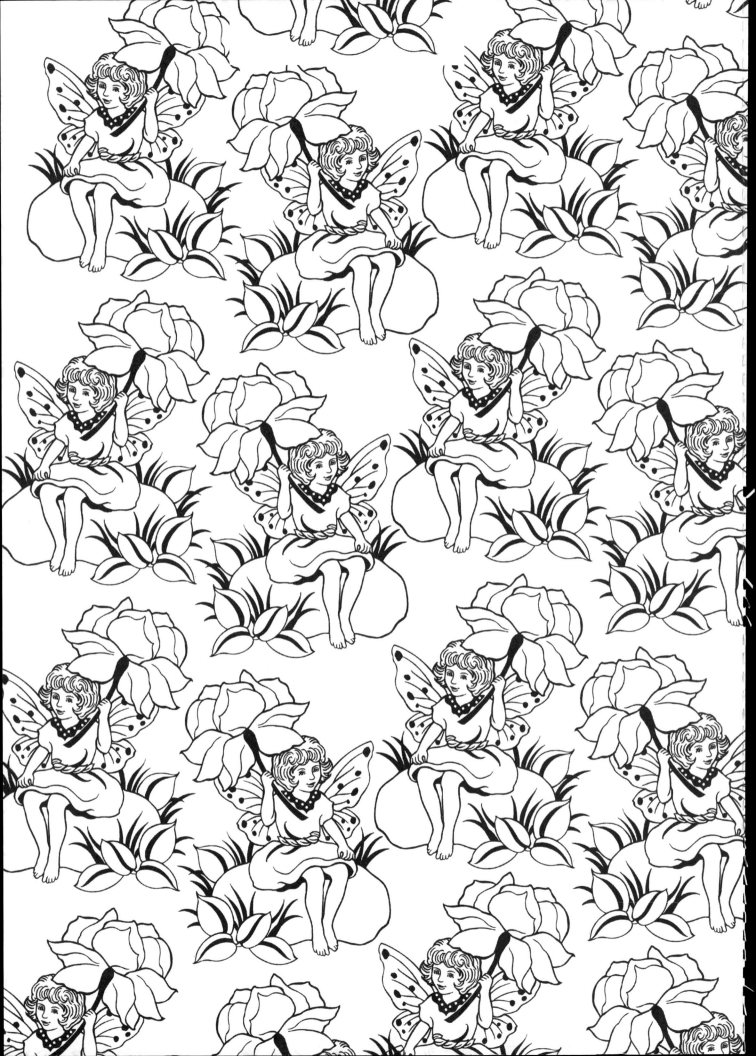

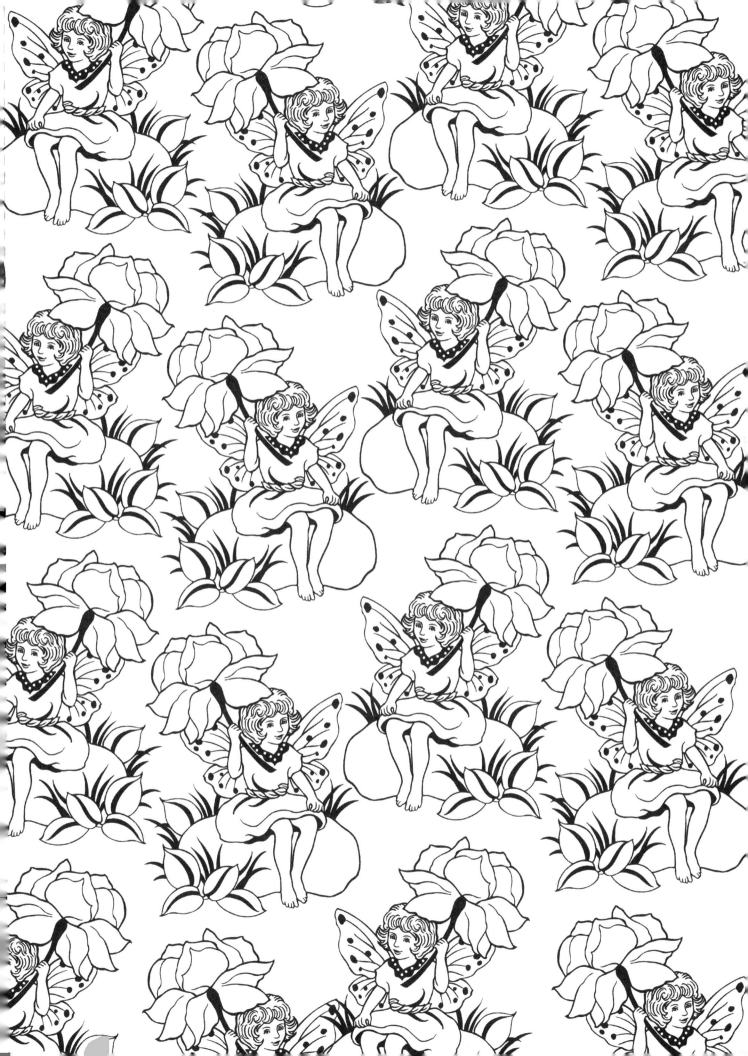

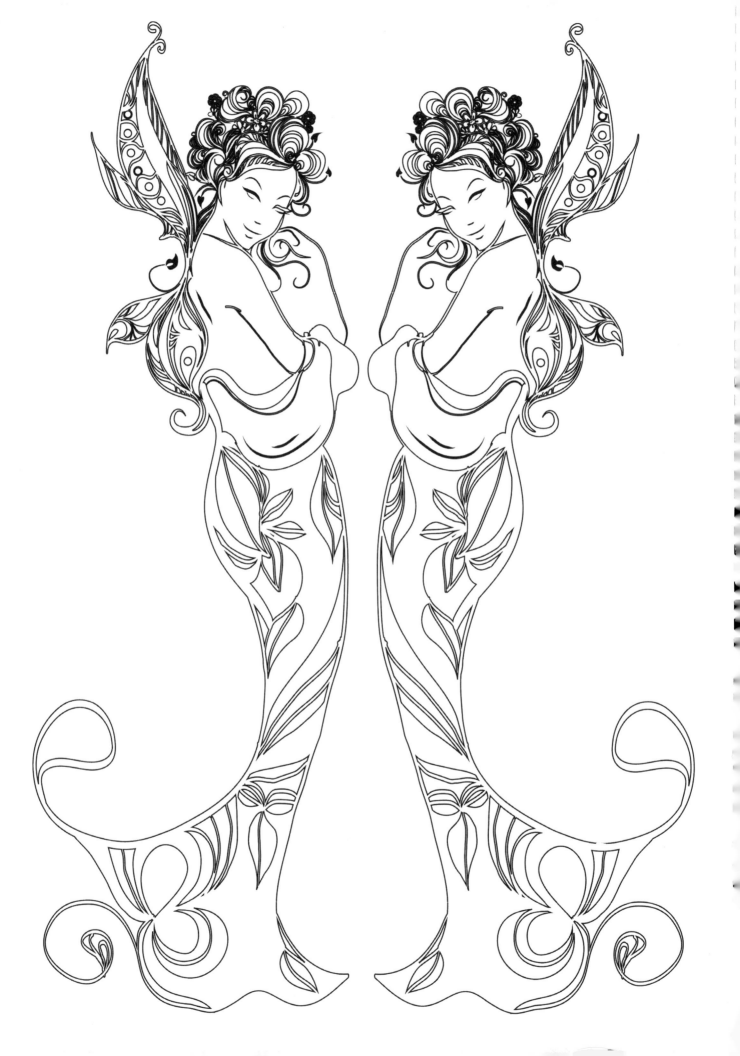

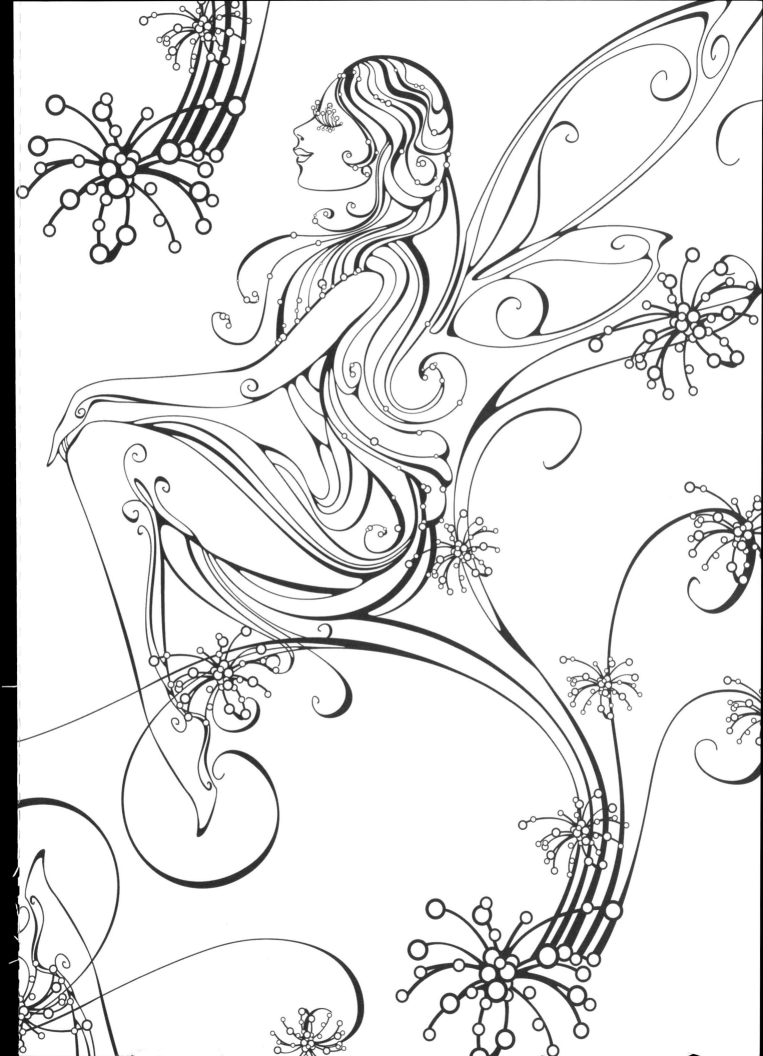

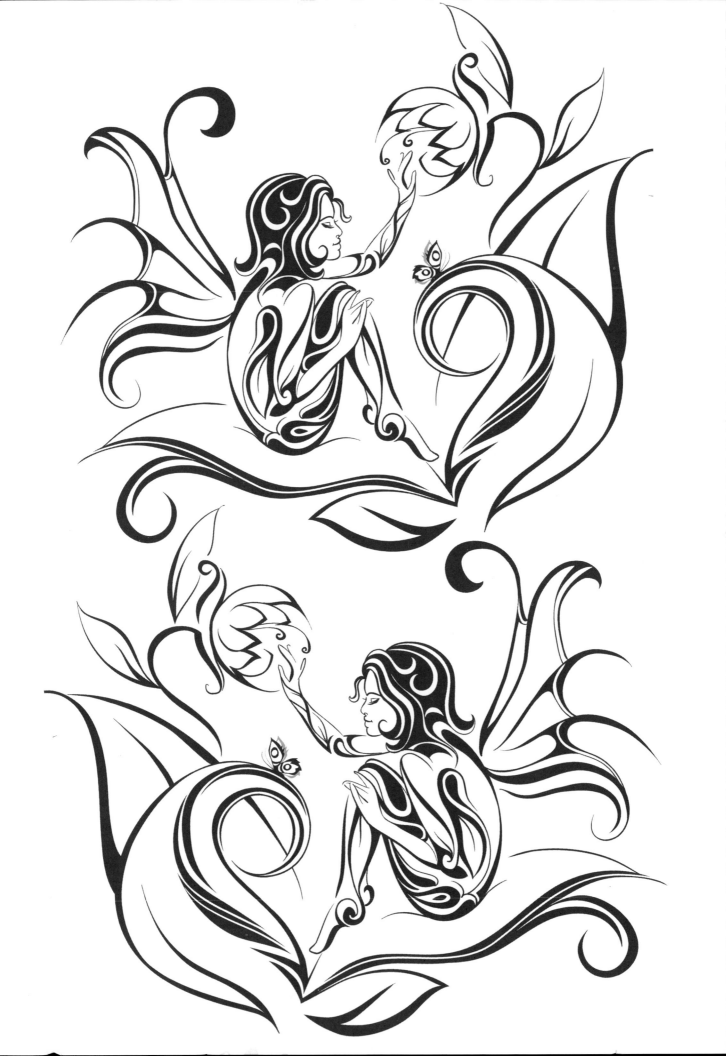

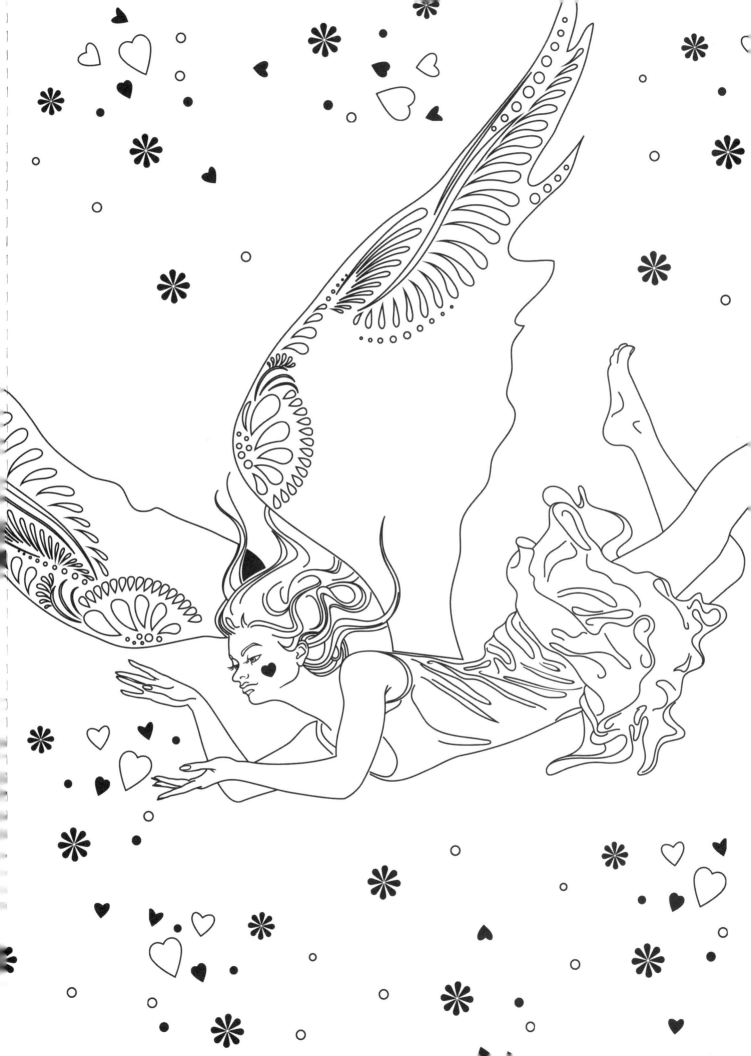

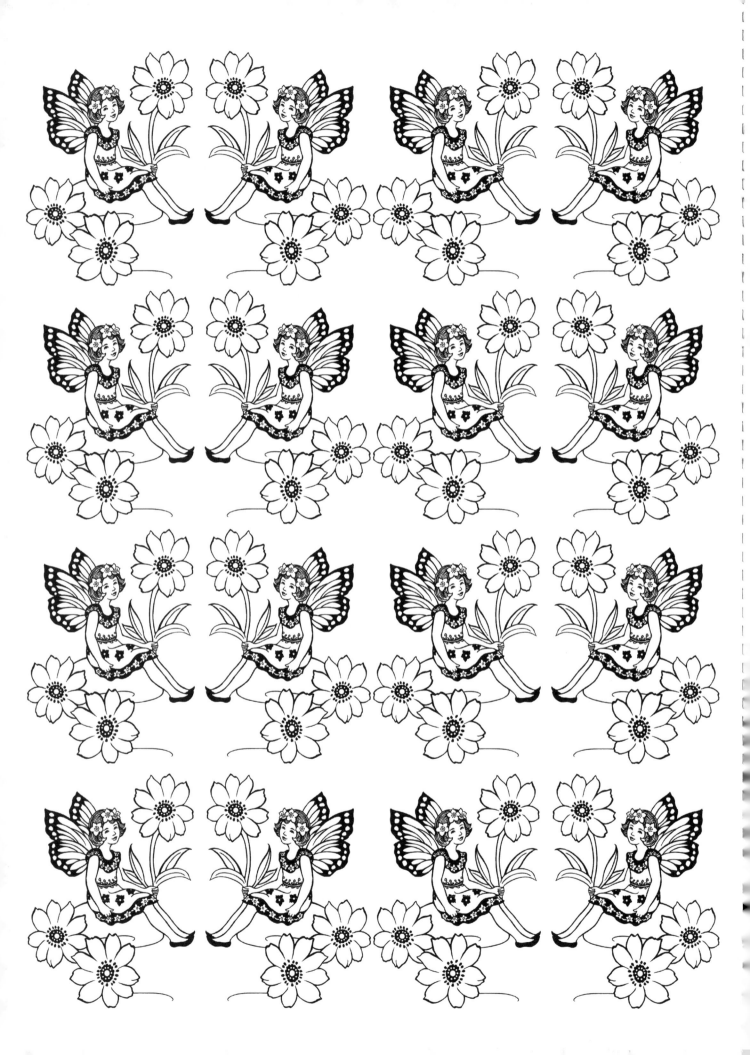

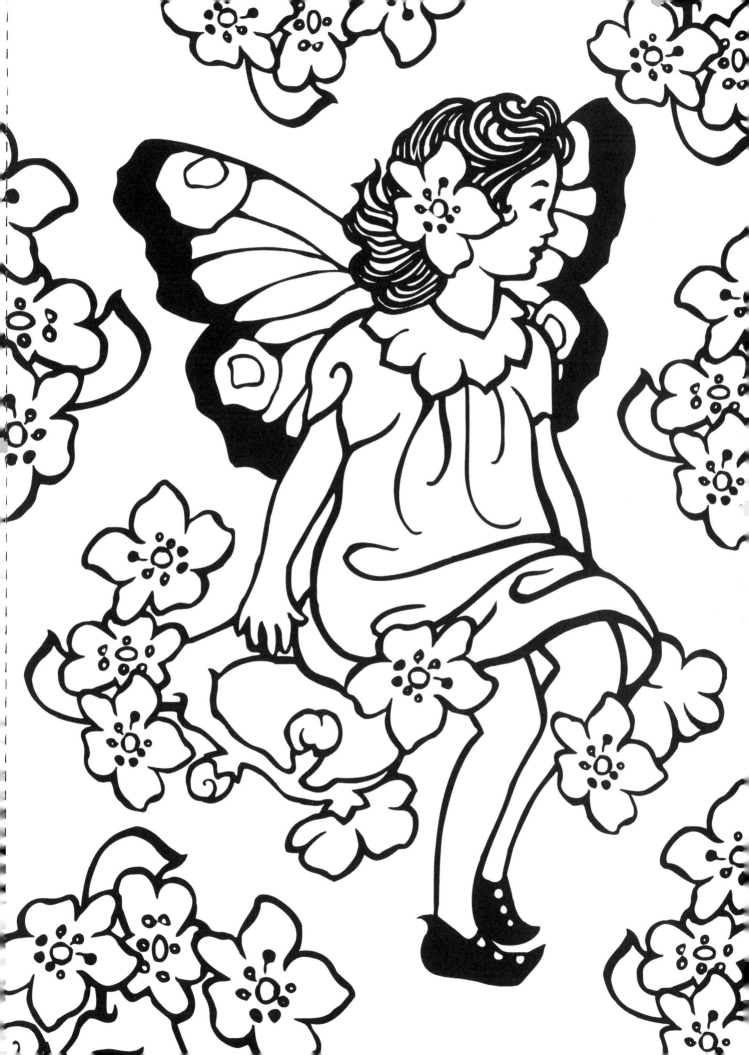

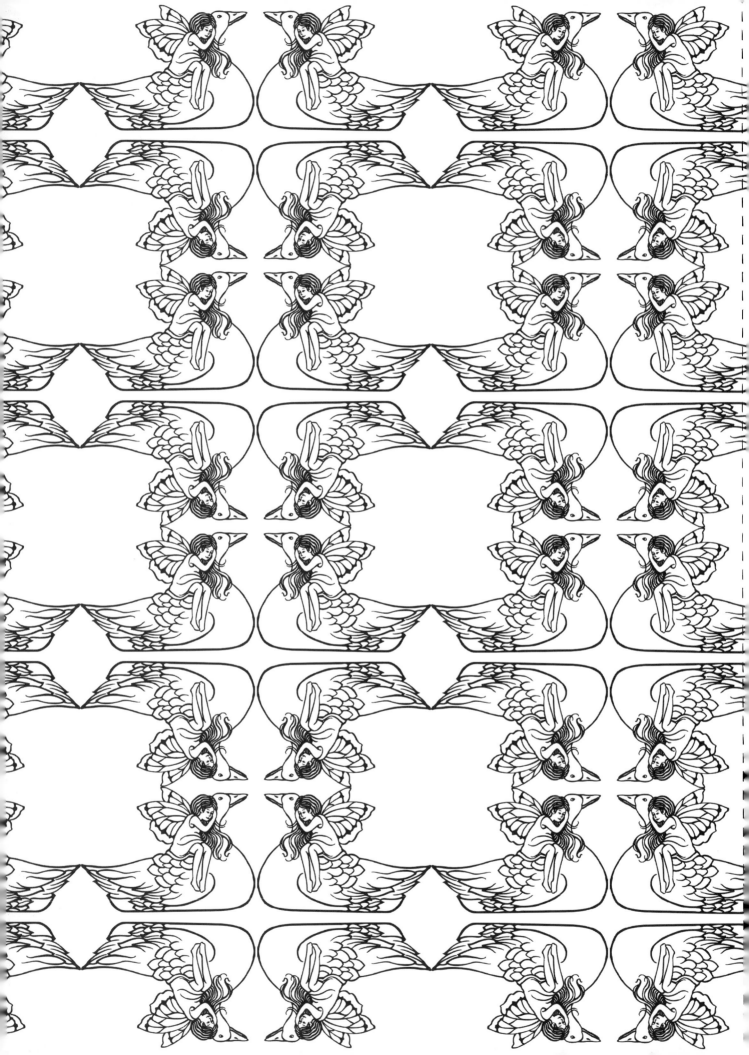

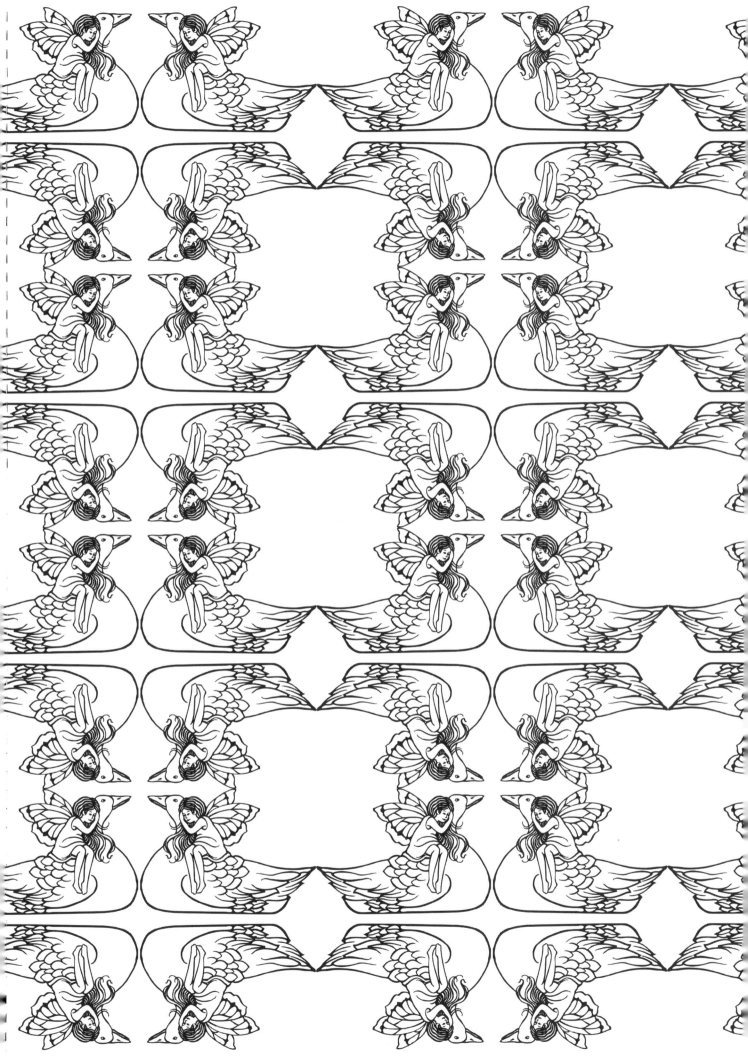

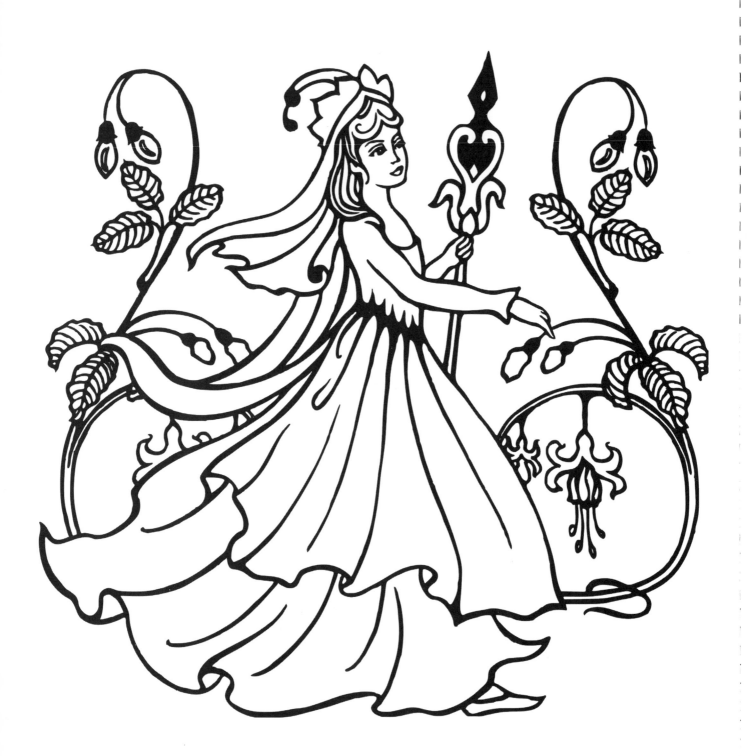

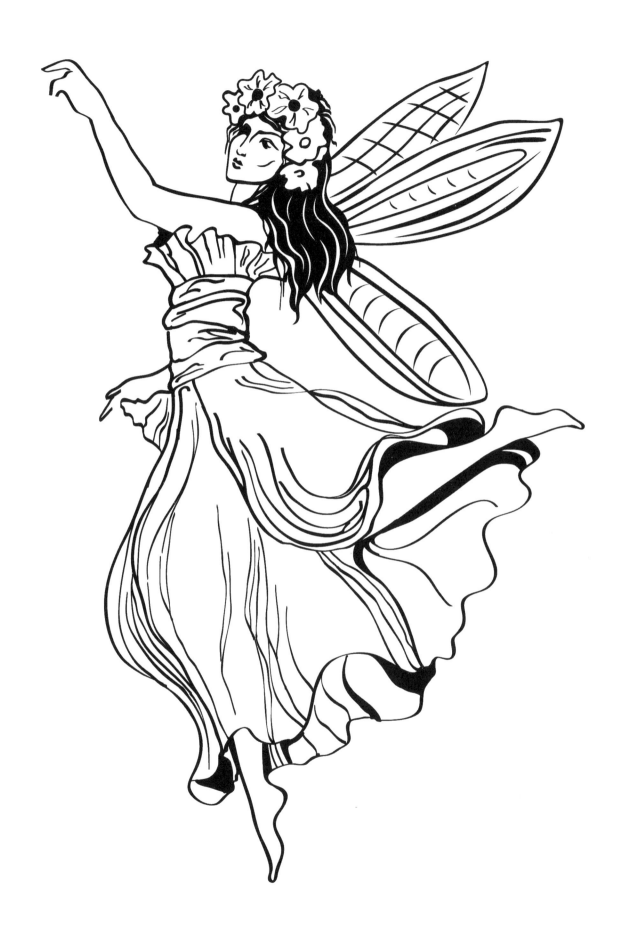

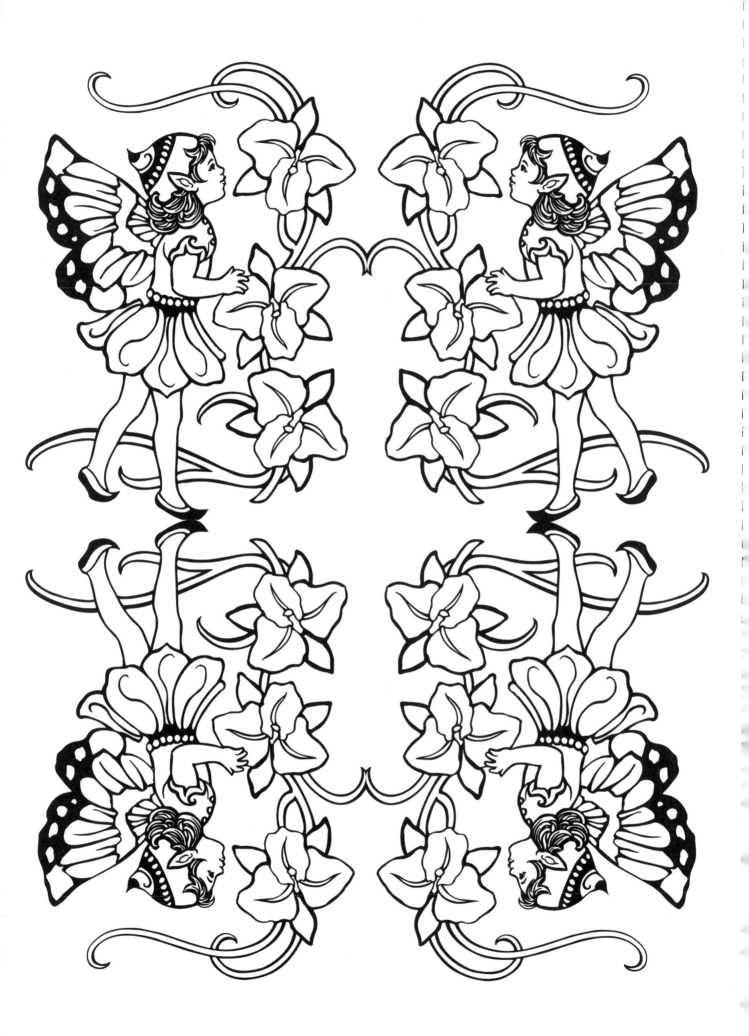

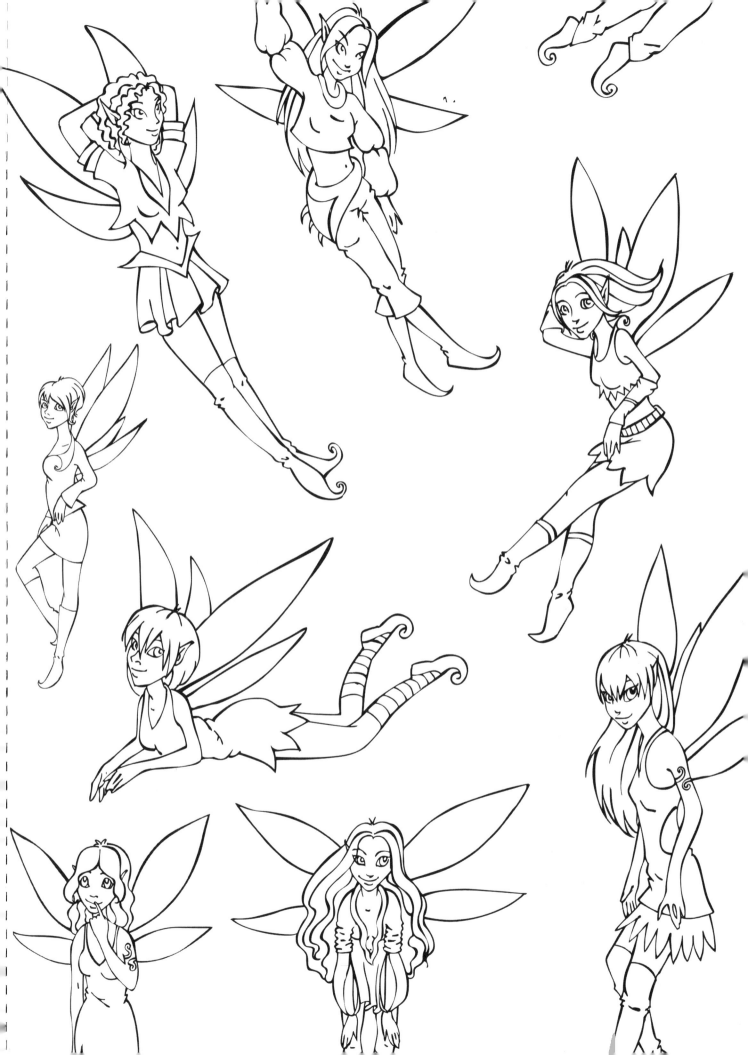

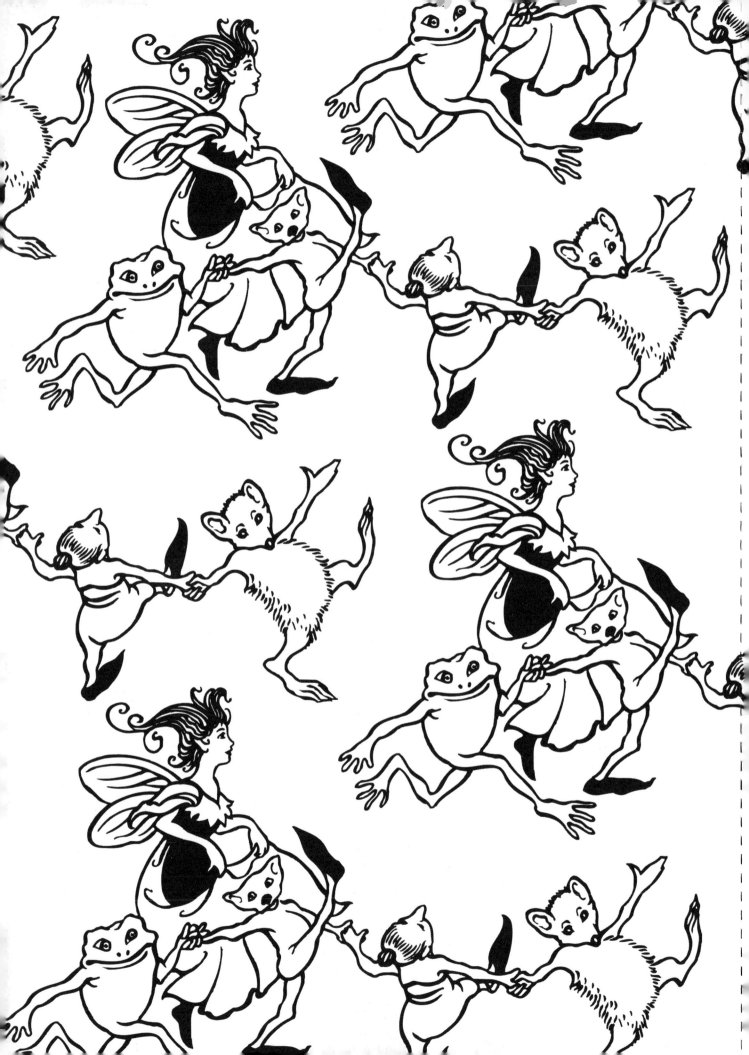

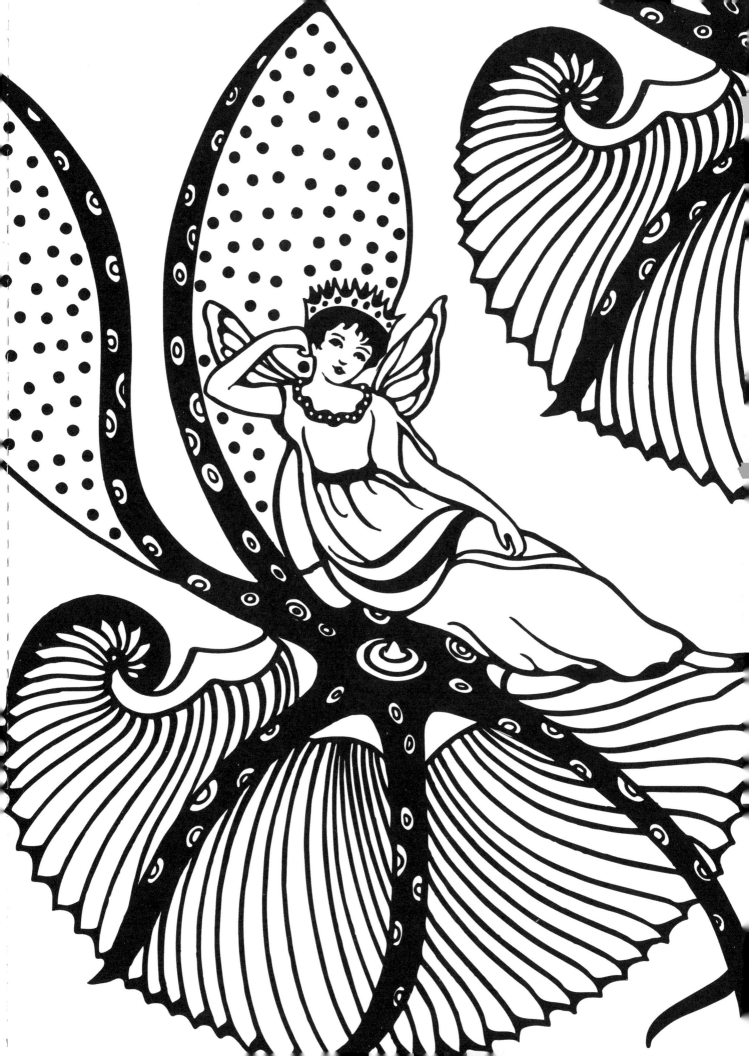

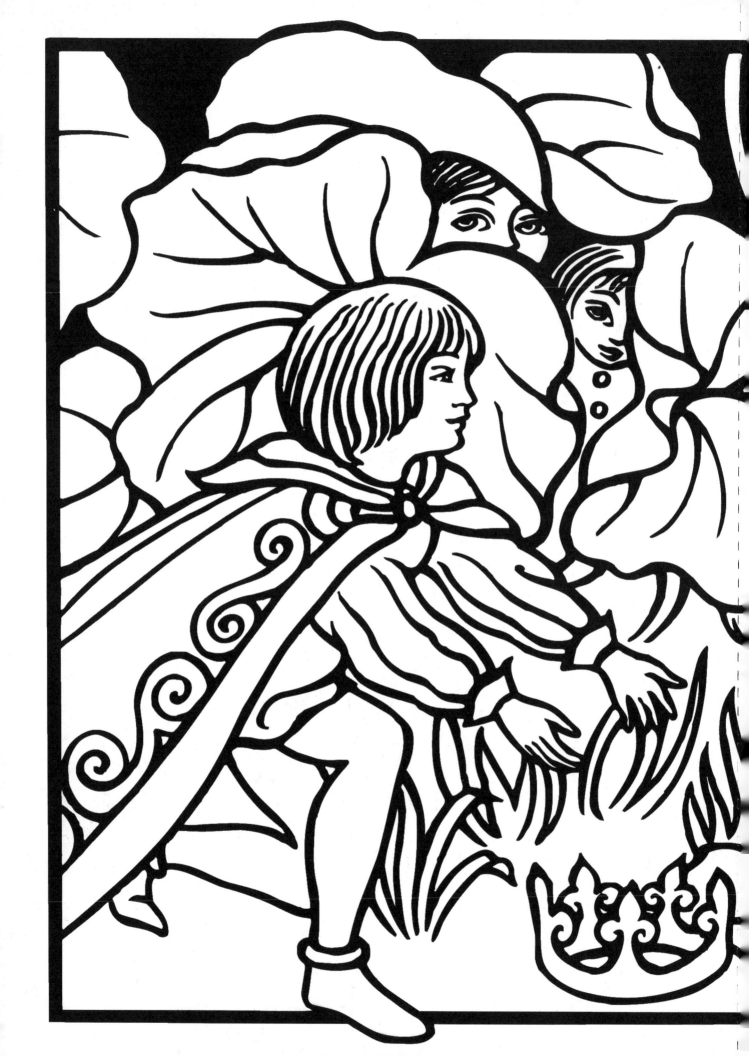

First edition for North America published in 2015 by Barron's Educational Series, Inc.

© Copyright 2015 by Carlton Publishing Group.

All inquiries should be addressed to:

Barron's Educational Series, Inc.
250 Wireless Boulevard
Hauppauge, New York 11788

www.barronseduc.com

ISBN: 978-1-4380-0760-1

Manufactured by: RR Donnelley Asia, Dongguan, China

Printed in China

9 8 7 6 5 4 3 2